P9-BZV-858

Oils

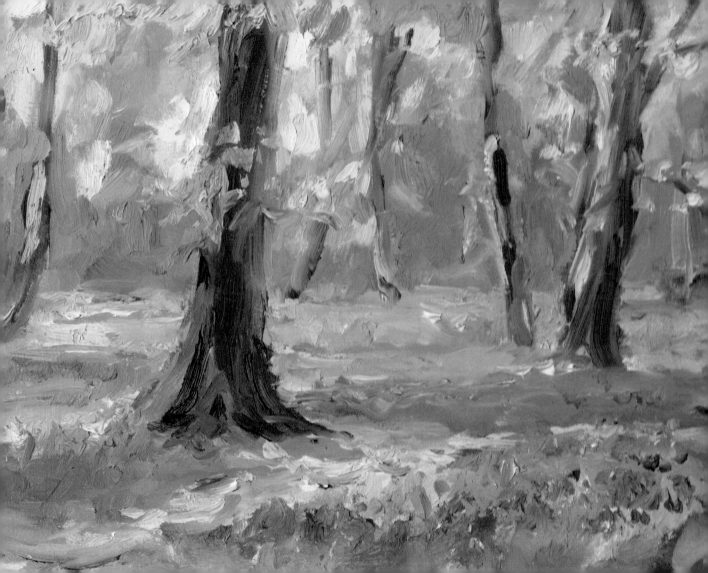

Oils

Melanie Cambridge

First published in 2010 by
Collins, an imprint of
HarperCollins*Publishers*
77–85 Fulham Palace Road
Hammersmith, London W6 8JB

www.collins.co.uk

Collins is a registered trademark of HarperCollins Publishers Limited.

14 13 12 11
8 7 6 5 4 3 2

A catalogue record for this book is available from the British Library.

Editor: Caroline Churton
Designer: Kathryn Gammon
Photographer: Richard Palmer

ISBN 978-0-00-730117-1

Colour reproduction by Colourscan, Singapore
Printed and bound in China

About the Author

Melanie Cambridge is best known
for her impressionist oil paintings,
particularly of marine subjects.
A founder member of the London-
based Maritime Art Group, she has
exhibited her work in London at
Llewellyn Alexander (Fine Paintings)
Ltd, the Mall Galleries and the
RAC Club, and also in commercial
galleries in the south of England.
As a tutor, she teaches in acrylics and mixed media
as well as oils. Based in Surrey, she runs workshops and
holidays in both the UK and abroad. This is her fourth
book for HarperCollins. For more information, visit
www.melaniecambridge.com

Dedication
To Peter for all his support and encouragement over the years.

Acknowledgements
My thanks to all at HarperCollins who have made this possible. Also to
Caroline Churton for her editorial skills and for keeping me organized, and to
Kathryn Gammon for her superb design work. Final thanks to Suzanne Gough
for allowing me to reproduce *High Summer, Polkerris* in this book.

Page 2: **Kingswood Bluebells**, 20 × 25.5 cm (8 × 10 in)

CONTENTS

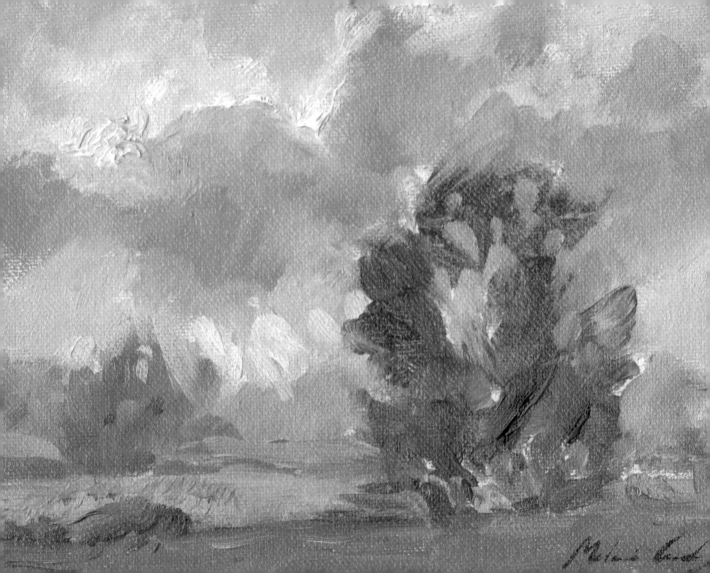

INTRODUCTION

Oil paints are a fantastic medium for working quickly as they are so versatile. They can be used either thickly or thinly to create a variety of different textures, and because oils remain wet for some time, changes are easy to make as you go along – ideal for quick studies and when painting outdoors, and for building confidence in the less experienced artist.

The simple guidelines in this book will show you how easy it is to create successful oil paintings in just one session, dispelling the myth that oils can be difficult and time-consuming to use.

◀ **Approaching Storm**
20 × 25.5 cm (8 × 10 in)
Using lively brush strokes to apply the paint directly to the surface with a minimum of fuss helped to create the strong sense of movement in both the sky and the trees.

The advantages of oils

Oils are such an exciting medium, capable of producing a wide range of creative effects. Oil paints come in tubes, making them easy to transport and use outdoors. Colours can either be applied thickly direct from the tube in the impasto style or thinned down to make lovely translucent glazes – the variety of textural effects possible is one of the great joys of oil paint. Large areas of colour can be quickly blocked in, helping you to establish the overall composition at an early stage in your painting.

Brush strokes tend to remain visible in oil painting, so the way in which you apply the paint and the direction of the brush strokes can define a figure, boat or tree quickly and easily without the need for too much detail. This is one of the many reasons why oils are the perfect medium for creating 30-minute paintings.

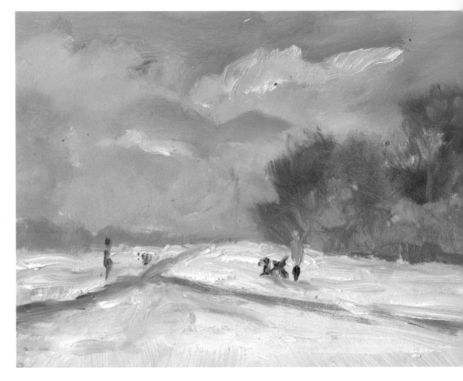

▲ **Winter on the Downs**
15 × 20 cm (6 × 8 in)
The bold impasto brush strokes used to portray the snow contrast with the thinly painted trees behind. The figures were put in with just a few simple flicks of colour.

The 30-minute challenge

Painting within a timescale of 30 minutes will help you to focus on your work and this in turn will enable you to capture the essence of a subject, rather than including everything that you see. In 30 minutes there will simply not be time to put in lots of detail. Working quickly will also help to keep your painting free and lively.

All the illustrations in this book took no more than 30 minutes' actual painting time; you will need to allow two or three days on top of this for the paint to dry. Before you start, spend a few moments thinking about what you want to paint. Look around carefully: what attracts your eye? Will it make a suitable subject? Once you have decided, keep this first thought in mind as you paint and do not be tempted to stray from your initial inspiration. Any other things you spot will probably be worthy of another 30 minutes of their own!

In this book you will find simple exercises to help you to paint quickly and with more confidence. Being able to produce a painting or study in 30 minutes will show you that no matter how busy you are you can always find time to paint. Whether you work at home from reference material or paint directly outdoors I hope this book will inspire you to produce successful oil paintings of your own.

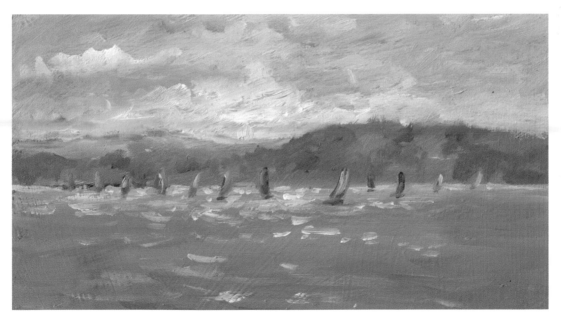

◀ **Dinghies, Osborne Bay**
20 × 25.5 cm (8 × 10 in)
Here single brush strokes were used to put in the sails, which effectively suggest the boats. The highlights on the water were applied in a similar way, resulting in a quick and simple study.

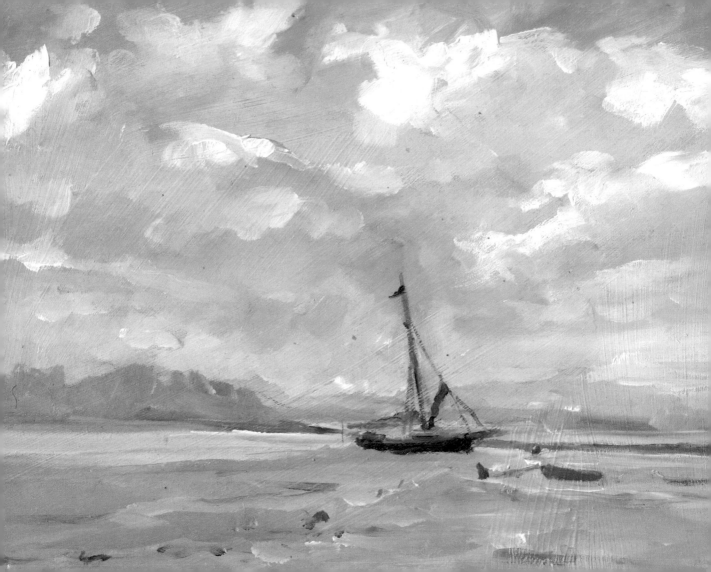

ESSENTIAL EQUIPMENT

When painting quickly, a few essentials are far more help than lots of unnecessary equipment that will clutter up your working area or weigh you down when working outdoors. In fact, all you need to get started are a limited selection of colours, just three brushes, a sketchbook and pencil or pen, and a few other useful bits and pieces.

Limiting your materials is especially important when working outdoors, but you can easily carry all your requirements in a small rucksack.This chapter introduces you to the basic equipment you will need to start working in this exciting medium.

◀ **Sunny Morning, Blackwater Estuary**
20 × 25.5 cm (8 × 10 in)
I painted this on a yellow-tinted board, leaving some areas of the surface visible in order to add life and warmth to the clouds.

Oil paints

Oil paints come in tubes of varying sizes and are available in different grades, either students' or artists' quality. Buy the best you can afford as artists' quality paints tend to contain more pigment, making the colours more vibrant and longer-lasting. However, students' quality paints represent excellent value for money and are fine when you are first starting out. Being mean with the amount of paint you use generally results in a poor painting, so if cost is an issue, choose students' quality paints and be generous with the amounts you use.

Alongside traditional oil paints, there are other modified paints now on the market. Two of the best-known types are alkyd oils and water-mixable oils, and both offer the artist specific advantages.

Alkyd oils

Alkyd oil paints dry faster than traditional ones. They are still an oil paint, but contain a modified and faster-drying oil binder. This makes them very practical when painting abroad, because unless you apply the paint extremely thickly it will usually dry overnight. For this reason, however, take care not to leave large blobs of unused paint on your working palette as these too may dry overnight, leading to a waste of paint. Alkyd oils are classified as non-flammable, making them particularly useful for the travelling artist.

Water-mixable oils

These can be thinned with a special medium and some water. Because the paints are in a modified oil base, any added water should be mixed thoroughly into the paint. Be careful to avoid over-thinning with water: this can cause problems as it may affect the molecular structure of the paint, resulting in a grainy wash effect. After all, oil and water do not generally mix!

Water-mixable oils are ideal for anyone with an allergy to turpentine or white spirit as brushes are cleaned in water, rather than these products.

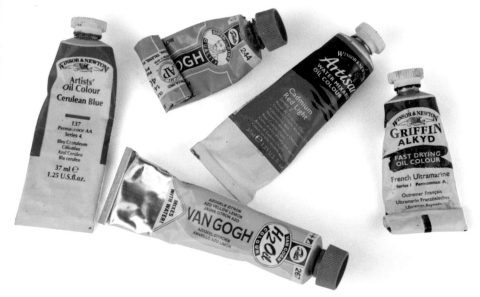

◀ A selection of traditional oils, alkyd paints and water-mixable oils.

Painting mediums

Traditionally, oil paints are thinned with a combination of turpentine and linseed oil. To keep things simple when working in just one 30-minute session I use a small pot of Winsor & Newton's Liquin Original. This is an alkyd medium (a commercial painting medium containing a spirit, oil and resin). It not only speeds up the drying time but also thins the paint to a sticky glaze, rather than a slippery wash, making it easier to apply two or three layers wet-in-wet and therefore finish a painting within one session.

Brush cleaners

You will need some white spirit for cleaning the brushes you use with oil paints and alkyd oils. Keep the lid on the jar when not in use to contain any strong fumes. You can also use a soap brush cleaner. If you are working with water-mixable oils, use water to clean your brushes.

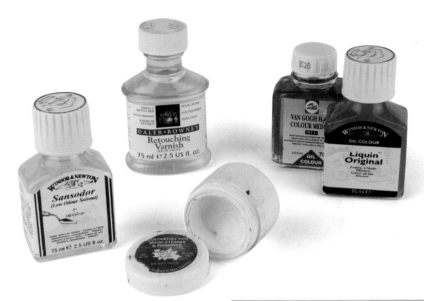

▲ Liquin medium, painting medium for water-mixable oils, retouching varnish, low-odour brush-cleaning solvent and soap brush cleaner.

Varnishes

As oil paint dries, certain colours 'sink' and can look flat and dull. Varnishing your painting will bring these dead patches back to life. Retouching varnish is ideal for this and is the only varnish I recommend. Unlike full-gloss varnish it can be overpainted, so if after varnishing your finished painting you change your mind and add more oil paint on top, there is no need to remove the layer of varnish first.

▲ Varnishing a picture brightens colours which have dulled on drying.

Brushes

When you begin painting in oils there is no need for lots of different brushes. Start with just three synthetic brushes, preferably long-handled, rather than ones made with traditional hog hair. Modern nylon brushes are an excellent choice as they have a springy feel and will keep their shape much better than hog-hair brushes. Choose a No. 7 long flat, a No. 4 round, and a No. 4 synthetic watercolour-style soft round brush for the fine details.

Flat brushes are particularly useful for working quickly: they are ideal for blocking in large areas with just a few strokes, yet if turned on to its edge a flat brush can also create a fairly fine line, such as for tree trunks or larger branches. Alternatively, you can use the edge of a painting knife to put in fine lines, such as for telegraph poles or masts and rigging.

Palettes

Oil palettes come in all shapes and sizes, so choose one that suits you; but remember that it needs to be big enough to hold all your colours and still leave plenty of space for mixing them. Traditionally, palettes are made of wood,

but you may find it easier to judge your colour mixes on a white plastic version. Disposable tear-off palettes can also be useful. It is a question of experimenting with various types of palette to find out which you prefer.

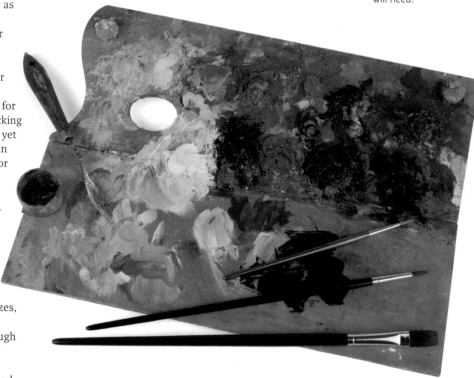

▼ Colours stay wet on the palette for up to a week, especially when generous amounts are put out as I have done here. This also shows the three brushes you will need.

Painting surfaces

There are several different surfaces that are suitable for oil painting, ranging from traditional canvas to more economic alternatives that you may find more convenient for quick oil studies.

Canvas

Stretched canvas will flex as you paint on it, making it a lively and responsive surface to work on. Buy ready-stretched canvases at your local art shop, rather than trying to prepare your own as this can be time-consuming. Canvases are fairly expensive, however, and for 30-minute paintings a painting panel or canvas board is just as suitable.

Canvas boards and panels

Primed boards covered in a thin layer of canvas are known as canvas boards and are widely available at art shops in a range of standard sizes. They are perfect for the first-time or inexperienced oil painter. Relatively cheap, yet with a good 'grippy' surface, they are my recommended surface for 30-minute paintings. In fact, most of the finished paintings in this book were done on primed boards.

Oil painting paper

A pad of oil painting paper is ideal for quick studies and colour-mixing

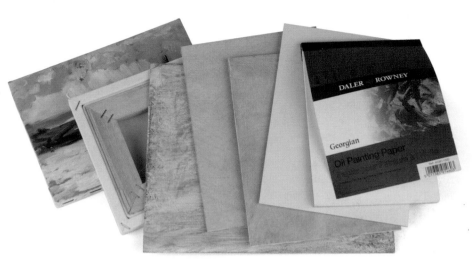

▲ Stretched canvas, primed boards and oil painting paper offer differing painting surfaces for the oil painter.

exercises. Unlike watercolour paper, the surface is textured to simulate canvas and coated with a special layer which prevents the oil paint sinking into it.

Acrylic paper

Although not strictly designed for use with oil paints, acrylic paper also has a textured surface and will accept them. As it is more absorbent than oil painting paper, the paint usually dries in a few minutes, making it easier to control the flow of paint when you are starting out. However, acrylic paper should be used only for quick studies as it is unlikely to remain stable over a long period of time.

QUICK TIP

When painting outdoors light can shine through the back of a canvas, making it difficult to see what you are doing. To prevent this, place a sheet of cardboard behind your canvas to block out the light.

Other useful items

There are a few other items that you will need or find useful. These include a sketchbook and a selection of pencils (2B, 4B and 6B), or a drawing pen if you prefer; a palette knife, which is useful both for mixing colours before you start painting and as a tool for making marks; a roll of kitchen paper or plenty of rags for cleaning brushes and wiping off paint (as well as a rubbish bag for disposing of them); and a camera for taking reference photographs. If you are painting outside in hot sunshine you might also include a sun hat and a cover-up shirt.

Outdoor essentials

Painting outdoors can be an absolute joy, but if you are weighed down with lots of heavy equipment, it can become something of a nightmare. Given that you will have a wet palette, at least one wet painting, various brushes and several tubes of colour, having the right painting box is essential if you are going to enjoy the experience.

▶ A pochade box holds everything you need for a day's painting outdoors.

The pochade box

The pochade box is the ideal solution. Named after the French word for 'sketch', this is a small painting box which will hold up to three wet painting panels, tubes of paint, brushes and a wet palette – fantastic for the 30-minute artist. Pochade boxes come in various sizes from around 15 x 20 cm (6 x 8 in) up to 30.5 x 40.5 cm (12 x 16 in). Each pochade box is designed to carry canvas boards of a particular size – I find a box that takes boards sized 20 x 25.5 cm (8 x 10 in) ideal. Any larger and the box tends to be too heavy or big to fit into a standard rucksack.

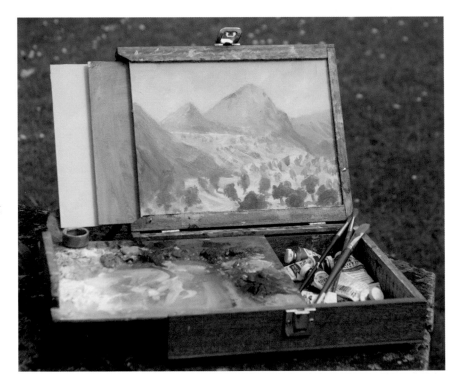

Box easel

A good alternative to the pochade box, especially if you wish to work on a slightly larger scale, is the box easel. Again, this has been designed to carry all your essentials, and the legs unfold to a standard easel height, enabling you to stand up and paint outdoors in comfort. There is even a sliding drawer to pull out and balance your palette on.

A full-sized box easel can be fairly heavy, weighing around 7 kg (15½ lb) when full. I use a half-sized version, which is lighter, but the palette has to be folded in half when not in use. I have adapted mine with a couple of cut-down wine corks so that when the palette is folded there is still some space between the two halves for blobs of unused paint.

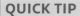

QUICK TIP

Be prepared for all weather conditions and wear suitable clothing to protect yourself from the elements. You might also want to take a hot or cold drink out with you.

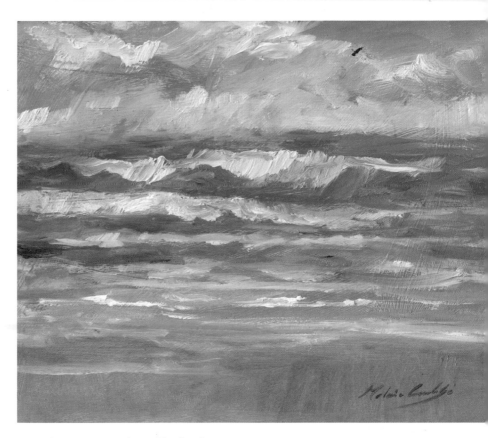

▲ **Cornish Surf**
20 × 25.5 cm (8 × 10 in)
I painted this whilst sitting on the sea wall with a pochade box balanced on my knees. The direction of the brush strokes suggests movement in the surf, whilst the use of impasto adds body.

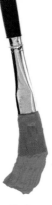

COLOUR AND TONE

Colour sets the mood of a painting and tonal values – the distribution of darks and lights – provide the structure. For a painting to be a success, both need to work together in harmony, especially when you have only 30 minutes in which to complete your composition.

Understanding how colour works and how you can manipulate it to achieve different moods are key skills to master. In this chapter you will find various exercises that will show you how to use both colour and tone to create paintings you can be really proud of.

◄ Southend Pier Against the Light
15 × 20 cm (6 × 8 in)
I sat in the car on a chilly winter's afternoon to paint this, using Coeruleum and Naples Yellow for both the sky and the water to provide strong tonal contrast with the Raw Umber and Coeruleum of the pier.

A basic palette

Primary colours are those which cannot be mixed from any others – for example, blue, red and yellow. If you mix two primary colours together in turn you will create purple, green and orange, which are known as secondary colours.

A simple palette containing just primary and secondary colours will help you to mix colours with more confidence and to paint quicker. Getting to know your palette will speed up your ability to mix colours successfully. Start by mixing each colour with every other colour in turn. Note the colours alongside each mix to create a personal colour chart.

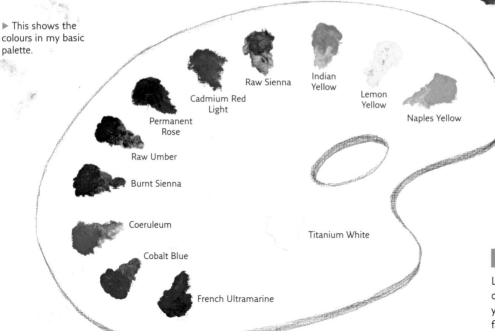

▶ This shows the colours in my basic palette.

Raw Sienna

Indian Yellow

Lemon Yellow

Cadmium Red Light

Naples Yellow

Permanent Rose

Raw Umber

Burnt Sienna

Coeruleum

Titanium White

Cobalt Blue

French Ultramarine

▲ The colour wheel here shows the three primary colours and secondary colour mixes. Colours which appear opposite each other are complementary.

QUICK TIP

Lay your colours in the same order on your palette each time you paint to help you to familiarize yourself with them and paint with greater confidence.

Complementary colours

Colours which are opposite each other on the colour wheel are known as complementary colours – red and green, yellow and purple, blue and orange. These colours contrast strongly and can be used to create vibrant effects when placed alongside each other in a painting. To understand how this works in practice, apply Coeruleum next to Cadmium Red Light; then try the same exercise with each set of complementary colours to see how strong the effect can be. The group of artists known as the Fauves were well known for using colour in this way.

Mixing softer shades

Complementary colours are also extremely useful where you wish to 'soften' a colour. For example, French Ultramarine can be a rather bright blue, but by adding just a little complementary orange the colour is changed very subtly, giving you a slightly darker and greyer shade which generally looks more natural in a landscape. I often adjust my colours in this way to avoid harsh synthetic shades in my paintings. It is a particularly effective way to create shadow colours, rather than by simply adding black to your mix.

◀ **Poplars and Shadows**
This quick study was painted in the Fauves style. By using complementary yellow and purple, rather than traditional greens, the overall effect is much more vibrant.

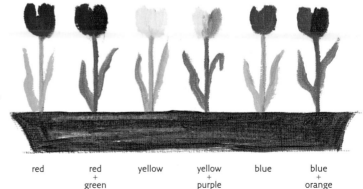

▶ **Tulips**
Each flower was painted with pure colour and then a little of its complementary colour was added for the shadows on the second flower in each pair.

| red | red + green | yellow | yellow + purple | blue | blue + orange |

COLOUR AND TONE | **21**

Mixing greys and dark colours

Grey shades or neutral tones are an essential ingredient in making your paintings look natural. Using complementary colours to mix these neutrals, rather than black and white, will give you a much wider range of subtle shades and avoid the deadening effect of pure black.

Grey shades mixed from blue and orange work particularly well for painting skies and clouds. To create colour harmony, use the same blue for clear areas of sky that you use to mix the grey shades for the clouds.

Dark colours

Using black to darken colours tends to deaden them. Instead, try mixing French Ultramarine and Burnt Sienna in various proportions to create a selection of interesting darks. The more blue you add to the mix, the darker and closer to black the resulting colour will be.

These examples show how you can mix different shades of grey by varying the blue used.

Coeruleum +
Cadmium Red Light +
Titanium White

French Ultramarine +
Cadmium Red Light +
Titanium White

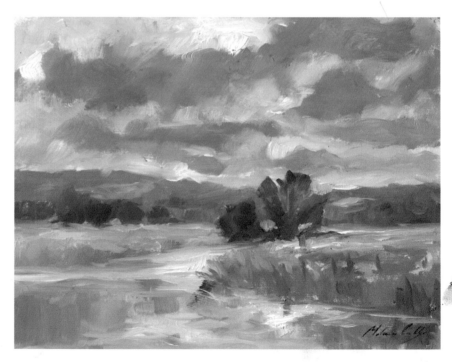

▶ **Clouds Over Send Marsh**
25.5 × 30.5 cm (10 × 12 in)
These clouds are a mix of French Ultramarine and Cadmium Red Light, with Titanium White added. I used the same colour for the water and in the surrounding greens to harmonize the landscape with the sky above.

Know your greens

Green is often the predominant colour in a landscape so it is a good idea to practise mixing this colour successfully. Blue and yellow, when mixed together, make a variety of green shades. Because blue is a very influential colour, the type of green you create will depend very much on the particular blue that you use. To discover this for yourself, try the exercise below, starting in turn with Indian Yellow and Lemon Yellow. Mix each colour first with Cobalt Blue and then with Coeruleum to produce the four greens illustrated.

Sometimes the green you mix may be a little harsh and unnatural – this can be the case with Coeruleum and Lemon Yellow – but by adding a very small amount of Permanent Rose the green can be softened so that it appears more muted. Practise this yourself and try to match the colours in my study below.

▶ These little studies of a pine tree, chestnut, poplar and willow show some of the many different greens that can be mixed from blue and yellow.

Cobalt Blue + Indian Yellow

Cobalt Blue + Lemon Yellow

Coeruleum + Indian Yellow

Coeruleum + Lemon Yellow

▶ I painted this chestnut tree first with Coeruleum and Lemon Yellow, then added just a little Permanent Rose to create a darker green.

Coeruleum + Lemon Yellow

+ Permanent Rose

QUICK TIP

Always start with yellow when mixing green and add the blue very slowly. Most greens contain more than 50 per cent yellow, even the darker ones.

Warm and cool colours

Reds, oranges and yellows are generally known as warm colours, whilst blues, purples and greens are cool. Warm colours tend to come forward in a painting, whereas cool colours recede into the distance. You can use this warm/cool balance to create a feeling of space within your paintings. Make your background colours much cooler – add more blue to distant hills and in your green mixes – and save your strong reds, oranges and yellow-greens for the foreground.

Temperature within colours
It is important to know that there are warm and cool versions of each colour. For example, Lemon Yellow is cooler than Indian Yellow (which contains more red pigment). Similarly, Coeruleum is much cooler than French Ultramarine. Being aware of the colour temperature of each colour on your palette will help you to understand how this can affect the final colour that you achieve in your mixes.

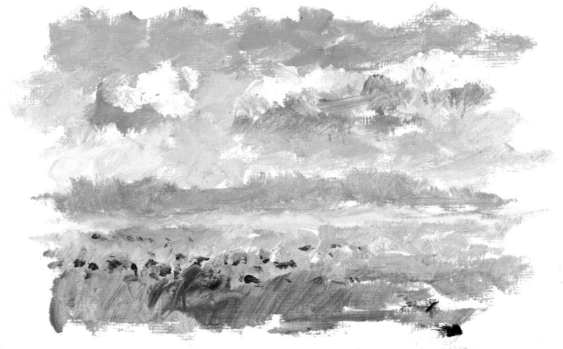

▶ **Cornfield**
8.5 × 14 cm (3¼ × 5½ in)
Cooler blues in the sky and hills help these areas to recede. See how the colour of the cornfield changes from the cooler Lemon Yellow in the middle distance to the warmer Indian Yellow and Raw Sienna in the foreground.

► These birds were painted in three different blues, with Coeruleum being the coolest. Cobalt Blue contains more red and is therefore warmer, and French Ultramarine is warmer still, becoming almost purple-blue.

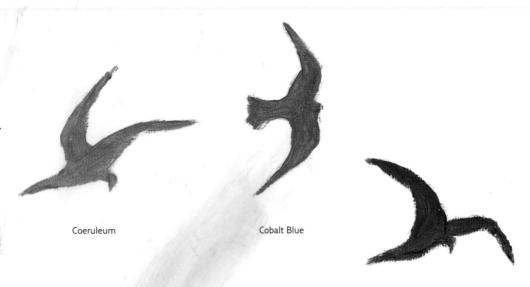

Coeruleum

Cobalt Blue

French Ultramarine

► These geese were painted in three different reds, with Cadmium Red Light being the warmest as it contains the most yellow. Cadmium Red Deep contains more blue and is therefore cooler, and Permanent Rose is the coolest colour.

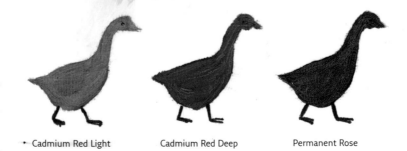

Cadmium Red Light

Cadmium Red Deep

Permanent Rose

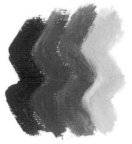

▲ This example shows harmonious colours.

Working with colour

Colour can be either calming and moody or vibrant and lively depending on how you use it. The exercises in this project will help you to understand colour and how to use it effectively to create different moods and atmosphere in your paintings.

Creating colour harmony
Colours which lie alongside each other on the colour wheel work in harmony when used together. To discover this for yourself, place several items of white crockery – perhaps a jug, cup and saucer – on the table in front of you. Use a combination of Cobalt Blue, French Ultramarine and Permanent Rose (with

◀ **Jug 1**
In this painting I used four colours which appear next to each other on the colour wheel to create a harmonious effect.

Titanium White) to paint them. Then try this exercise again, but this time use brighter shades – Lemon Yellow, Indian Yellow and Cadmium Red Light. Whilst the colours are different, the degree of harmony will be the same.

Using harmonious colours in this way can also be very effective for portraying sunsets and when painting morning mist. Try to restrict the number of colours you use to no more than four otherwise the harmonizing effect may be lost.

Using vibrant colours

Complementary colours – those opposite each other on the colour wheel – contrast strongly when used together. To create a vibrant scene, try using just two complementary colours. Set up a simple still life on a table and light it from one side with an angle lamp. Paint all the shadow areas with Coeruleum and all the lit areas with Cadmium Red Light. See how they 'vibrate' against each other, whilst still describing areas of light and shade. Repeat the same exercise with the other two combinations of complementary colours – red and green, and yellow and purple.

▲ This example shows more striking complementary colours.

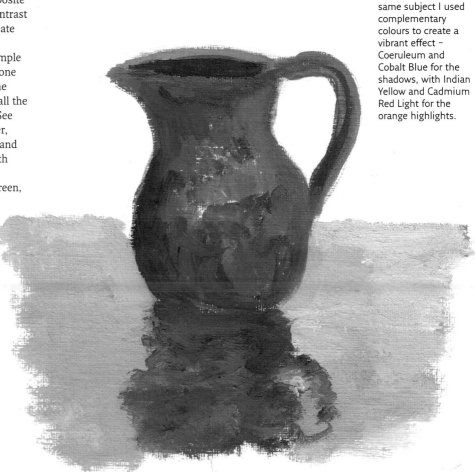

▼ Jug 2
In this study of the same subject I used complementary colours to create a vibrant effect – Coeruleum and Cobalt Blue for the shadows, with Indian Yellow and Cadmium Red Light for the orange highlights.

Tonal values

Tonal value refers to how dark or light a colour is relative to the grey scale. To help you to understand this principle, paint a simple tonal scale of, say, five tones on a strip of card, as I have done here. Use this to judge the tonal values of the colours in your subject. Half-close your eyes to enable you to see these more easily and aim to trust your first judgements when you are painting. You may find it useful to give each tonal value a number, so that as you look at your subject you can compare the tone of a particular colour with the equivalent tone on the scale.

I have tried to show you how this works in practice in the three studies on this page, by painting a familiar object and then putting a spot of grey of the same tonal value alongside it.

Looking for tones

The more you practise looking for tones in your subjects, the easier you will find it becomes. Start by selecting several differently coloured objects from your home and make simple paintings of each of them. Paint the colour as accurately as you can. Then half-close your eyes to help you to focus on the tones. Using French Ultramarine, Burnt Sienna and Titanium White, mix a grey shade to match the colour of each object and place it alongside your painting as I have done here. Assess your work to decide whether you were successful in converting each colour to a grey of the same tone.

◀ **Lemon**
The bright yellow of the lemon equates to a light-grey tone, even though it is a strong colour.

◀ **Carrot**
The orange of the carrot relates to a mid-grey tone.

▲ This tonal scale of five shades ranges from white to darkish grey, rather than black, as this is the deepest tone I use for landscapes.

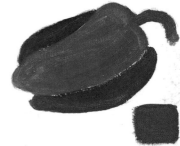

▶ **Pepper**
The dark green of the pepper translates to a dark-grey tone, as it is a more subdued colour.

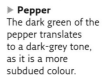

Using a limited tonal range

Restricting the number of different tones within a painting will help you to simplify what you see and so paint quicker and with more confidence. It can also be useful in creating mood. For the painting of the River Thames embankment shown below I deliberately kept all of the tones within a small range and then brought the painting to life by using one contrasting colour for the light on the water and the highlights on top of the moored boats.

◀ **Evening Light, Thames Embankment**
20 × 25.5 cm (8 × 10 in)
Coeruleum and Cadmium Red Light predominate here to create an overall harmony of cool shades. The highlights on the water were painted thickly to bring them forward, yet still tinted with Coeruleum to keep them in balance with the rest of the painting.

29

Creating mood and atmosphere

A combination of tonal range and colour can be used to create different moods in your paintings. On a sunny day you will see a wide range of tones from the lightest to the very darkest, and probably a broad selection of colours as well. In the late evening, however, not only do colours tend to be more muted, but the tonal range is also usually much less. By using a limited tonal range and also restricting the number of colours, you can create a much more atmospheric painting in which the odd touch of bright colour will stand out to greater effect.

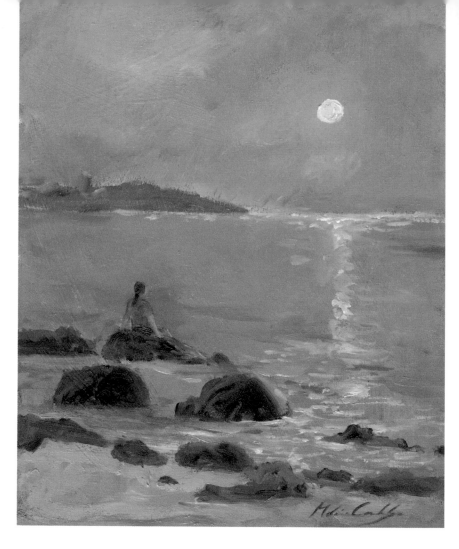

▶ **Swedish Sunset**
25.5 × 20 cm (10 × 8 in)
I used Raw Sienna and Permanent Rose with Titanium White for both sky and water to create harmony and a feeling of warmth, before adding the sunlight with Indian Yellow. The figure on the foreground rock provides a sense of scale without being too dominant.

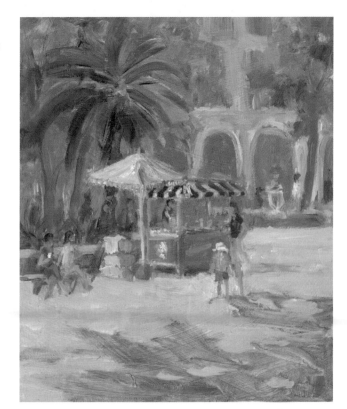

▶ Ice Cream Seller, Nerja, Spain
25.5 × 20 cm (10 × 8 in)
Strong sunlight in the foreground was achieved by using bright colours and a wide range of tones. The buildings in the background were painted in soft neutral tones. This broad tonal and colour range is the key to capturing the atmosphere of this sunny scene.

Portraying depth and distance

Because the tonal range is much wider on a sunny day than on an overcast one, with dark shadows contrasting sharply with the bright sunlit areas, it is easy to let the strong colours take over. Before you start painting, look carefully at the scene in front of you, especially the background. Colours here will still be softer, with less detail and perhaps a little bluer than those in the foreground. You need to emphasize these differences to keep a sense of depth and distance in your painting.

QUICK OVERVIEW

☐ Keep to a few colours at first until you become familiar with mixing them.

☐ Mix complementary colours to make greys, rather than using black.

☐ Use cooler colours for the background to make it recede, with warmer shades in the foreground.

☐ Make a tonal scale to help you to judge the tones in your paintings.

☐ Use tone and colour to create atmosphere in your work.

Creating mood

You can use tones to create mood in your paintings by keeping colours in close harmony and using only a limited tonal range. Here the warm orange background of the board helps to establish the feeling of a sunset, contrasting with the purples in both the clouds and the marsh.

MATERIALS USED
No. 7 long flat brush
No. 4 round brush
Painting board, tinted with warm orange
Charcoal
Alkyd medium
Cobalt Blue
Burnt Sienna
Titanium White
Permanent Rose
Raw Sienna
Coeruleum
Indian Yellow
French Ultramarine

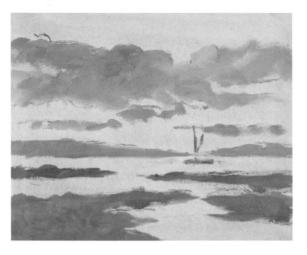

1 Draw in the main composition with charcoal and then paint the clouds with the flat brush, using Cobalt Blue, Burnt Sienna and Titanium White. Do not add any cloud highlights at this stage. Next, put in the marsh grasses, using a fairly dark purple tone mixed from Cobalt Blue, Permanent Rose and Raw Sienna. Add a little Titanium White to this mix to paint the distant hills beyond the boat.

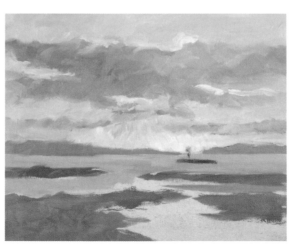

2 Mix Coeruleum and Titanium White for the sky above the clouds. Add the sunset colours, using Indian Yellow, Permanent Rose and Titanium White. For the rays of light under the lowest clouds, use thick impasto vertical brush strokes of Indian Yellow and Titanium White. Next, paint the water with a lighter version of the marsh colour, and then put in the hull of the boat, using Burnt Sienna and French Ultramarine.

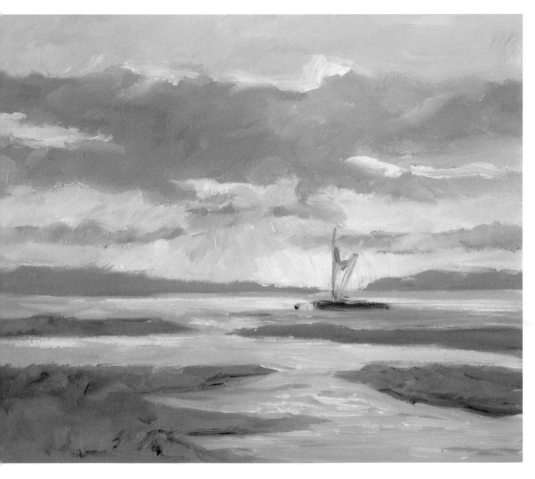

3 Put in the foreground water as a flat area of colour. Switch to the round brush and paint a few darker ripples. Add some highlights to the distant water, using short impasto brush strokes and a mix of Indian Yellow, Permanent Rose and Titanium White. Finally, add the boat's sail with Burnt Sienna and Titanium White.

◀ **Sunset Over the Marshes**
20 × 25.5 cm (8 × 10 in)

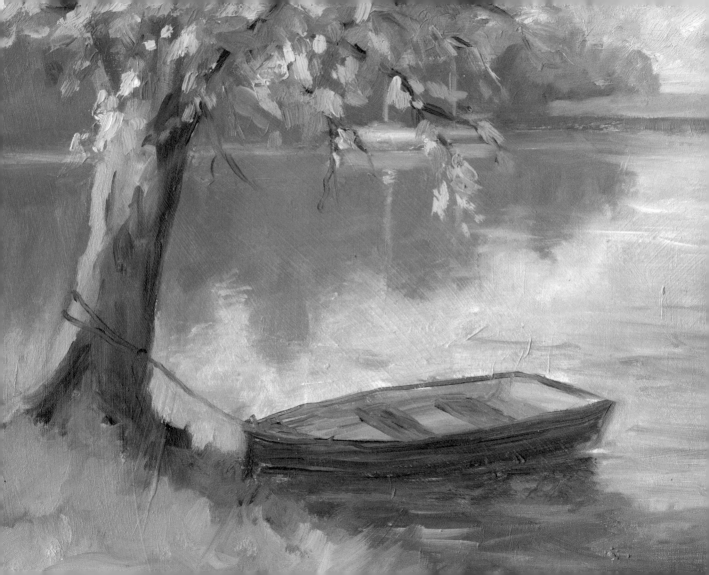

TECHNIQUES

Handle your brushes with confidence and anything is possible! Oil paint is such a forgiving medium, adaptable for use in so many different ways, from wonderfully translucent glazes to thick impasto marks where the brush strokes are clearly visible.

This chapter will guide you through the basic techniques you will need to produce quick and successful paintings. As your confidence in handling both brushes and paints develops, you will find it much easier to paint quickly and will amaze yourself at how much you can achieve, even in 30 minutes.

◄ **A Quiet Spot, Northern France**
20 × 25.5 cm (8 × 10 in)
Softly blended brush strokes were the key to the reflections here. The dinghy provides a sense of scale, whilst the vibrant patches of lime green on the tree contrast with the more muted colours of the water.

Brush strokes

In oil painting the marks you make help to define your individual style. Particularly when you are working quickly, a single brush stroke can pick out a figure or distant tree, so mastering a confident brush technique is a key skill in your development as an oil painter.

There is more than one way to hold a brush, especially the long-handled flat that I recommend you use as your main brush, and the way you do so will affect the type of brush stroke you produce. A wide variety of brush strokes keeps the surface of your painting lively and interesting, as well as helping to bring out your own unique painting style, so let's look at the two main options for holding your brush.

Traditional hold

The most obvious way to hold a brush is the same way that you hold a pen when writing. This is fine for relatively short, controlled brush strokes and detailed work, but can be restrictive when blocking in big areas of colour.

▲ Holding the brush in the traditional way is generally best for producing more controlled brush strokes.

The over-hand hold

In order to paint a picture in 30 minutes larger areas of the painting surface will need to be blocked in quickly. Using the over-hand hold makes this much easier as it enables your arm to move more freely from the shoulder. Imagine that you are the conductor of an orchestra and wave your arm about as if conducting. This same movement of hand and arm also produces lively brush strokes. Try it on a sheet of paper and see how easily and quickly you can cover the whole surface.

▶ Using the over-hand hold encourages looser brush strokes and is ideal for covering the surface quickly.

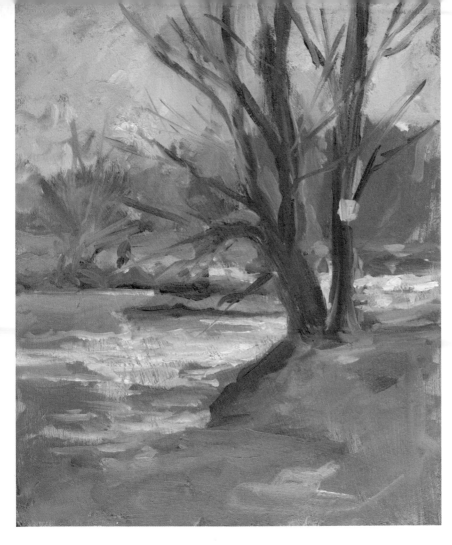

◀ Winter River
25.5 × 20 cm (10 × 8 in)
Here the sky and
distant riverbank
were painted first.
I then added the
foreground tree,
using light pressure
on the brush and
lively brush strokes
painted directly into
the wet background.

QUICK TIP

Position your painting surface
upright on an easel to give your
arm extra room to manoeuvre.
Loose, free brush strokes are
difficult to achieve when working
flat on a table.

Wet-in-wet

Oil paint dries slowly over several days, so any painting done in 30 minutes will naturally be painted entirely wet-in-wet. Techniques to cope with this are essential for the 30-minute artist.

When painting wet-in-wet, always start with your darkest colour as this needs to be painted on to a dry surface if it is to remain dark; adding dark paint on top of still-wet lighter colours can result in chalky-looking mid-tones, rather than truly dark colours. If you do need to put in dark colours over light, however, take a small rag and wipe off any wet paint first.

Thin your paints only when you have to, not as a matter of course. Over-thinning oil paint can make it very slippery and consequently almost impossible to overpaint when wet, so use a medium only if the paint will not flow sufficiently on its own. Paints thinned with alkyd medium (Liquin), rather than turpentine, remain sticky, making it easier for you to add a second layer.

Overlaying colours

The simple exercise here will help you to create different effects when overlaying colours. Start by painting an area of solid colour, then very gently paint a series of white lines and blobs on top. Repeat the exercise, painting a solid area of blue. This time, add yellow on top with moderate pressure on your brush. See how the yellow blends with the underlying blue to create a green mark. The more pressure you use, the more the two colours will mix together on the surface.

◀ I used very gentle pressure when painting the white lines on to the magenta, but much more pressure overpainting the blue with yellow so that these two colours mixed together on the surface.

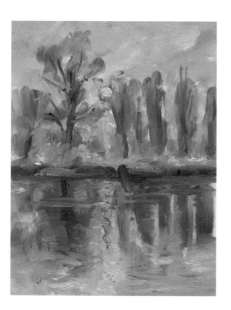

◀ **Sunlit Trees**
20 × 15 cm (8 × 6 in)
This 10-minute study was painted as the sun was sinking behind the trees. The ripples on the water were put in with single brush strokes applied directly into the wet paint of the reflections.

Blending

One of the joys of oil paint is the ease with which colours can be blended together. When using this technique, aim to add the least amount of thinning medium necessary to allow the paint to flow. Moderate pressure on the brush will also help you to blend colours together softly. If you press too hard, sometimes colour will be lifted off the surface, rather than mixed on it.

The exercise here will show you how to develop your skills in blending colours. Start by applying some yellow to your painting surface. Add the minimum amount of thinner and use smooth vertical brush strokes with only moderate pressure. Clean your brush and paint a strip of blue alongside the yellow, using the same method. Clean your brush again. Still using vertical brush strokes, gently blend the two colours together until you have a softened line between them. This technique is very effective for painting reflections in calm water.

▶ **Quiet Mooring, River Wey**
25.5 × 20 cm (10 × 8 in)
The reflections here were painted using vertical brush strokes, with the colours softly blended together until they appear to melt into each other. Gentle pressure on the brush and the use of only a little medium helped to achieve this.

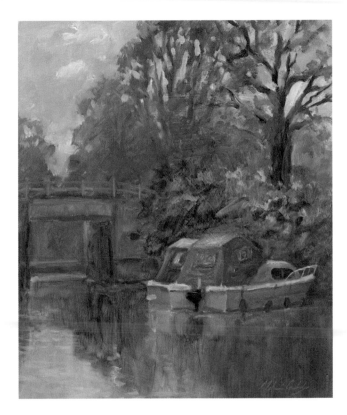

▶ This example shows vertically blended brush strokes of yellow and blue, resulting in a gradual transition from one colour to the other.

QUICK TIP

Light colours appear a little darker when reflected, whilst dark colours tend to look slightly lighter.

Hard and soft edges

Where two colours meet, an edge is formed between them. The type of edge can vary and falls into one of three categories. The first of these is a hard edge, such as the sharp profile of a building, where the colours are clearly separate with no blending where they meet; the second is a much softer edge, such as in clouds, where colours are gently blended together. Where a less obvious overlapping of colours is appropriate, smudging them together with your finger can be a good way to achieve this. The third type of edge is known as a lost edge, where colours are blended so softly that their edges disappear completely. This can be very useful for depicting mirror-like reflections in water or on a wet beach.

▼ **Sunlit Barge**
15 × 20 cm (6 × 8 in)
The highlights on the clouds were painted with hard edges, contrasting with the blue sky, whilst I used my finger to blend the grey undersides of the clouds into the sky below.

▼ These examples show the three different types of edges.

Hard edge: each colour is clearly defined

Soft edge: the colours blend together where they meet to provide a gradual transition

Lost edge: the colours blend seamlessly into each other with no defined line between them

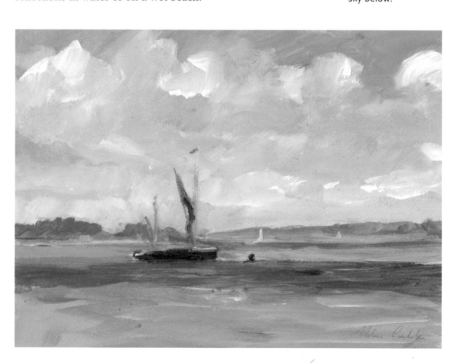

Impasto

The technique in which paint is applied thickly straight from the tube, without any added medium, and where the brush strokes stand out clearly is known as impasto. It is generally used for highlights, such as sunlight catching the edge of a flower or building. Impasto marks tend to be less effective for shadows, so save them for the lightest and brightest areas in your paintings. They can also be applied with a painting knife, rather than a brush.

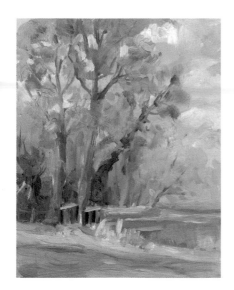

◀ **Summer Trees**
15 × 10 cm (6 × 4 in)
Thickly applied impasto brush strokes were used to emphasize the sunlight on the left-hand side of the tree and the tops of the clouds.

Translucent and opaque colours

Oil paints consist of powdered pigment blended with an oil binder. The translucency or opacity of each colour varies according to the pigment: symbols on each tube of paint provide this information. Translucent colours are ideal when you want to apply thin glazes, whereas opaque paints are better for covering large areas with solid colour.

Working with transparent colour
In oil painting thin glazes of dark colours tend to have more effect than dark colours applied heavily. This is because the thinned colour enables light to pass through to the painting surface. Subtle differences in dark colours are more apparent when the paint has been applied in this way. The contrast between thinly applied darks and thickly applied highlights adds interest to the painting surface and gives greater emphasis to the highlighted areas.

◀ Permanent Rose is a fully translucent colour, so the white of the underlying surface shows through easily; Cadmium Red Light is semi-translucent; Coeruleum is semi-opaque; and Lemon Yellow is fully opaque.

QUICK OVERVIEW

☐ Practise different brush holds to see how these affect your brush strokes.

☐ Apply dark colours before light when working wet-in-wet.

☐ Use less pressure on your brush when overlaying colours.

☐ Use blending to create soft or lost edges in your paintings.

☐ Paint from thin, translucent darks to thick, opaque highlights.

Combining techniques

So far we have looked at the basic techniques for handling oil paint. Now let's put them together in one painting. In this garden scene glazes of darker colour help to emphasize the thick impasto of the flower heads, whilst soft blending is useful for creating the underlying foliage.

MATERIALS USED

No. 7 long flat brush
No. 4 round brush
Painting board, tinted
 with Raw Umber
Charcoal
Alkyd medium
French Ultramarine
Indian Yellow
Cobalt Blue
Lemon Yellow
Titanium White
Burnt Sienna
Permanent Rose
Raw Umber

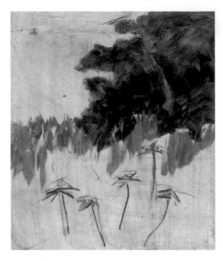

1 Mark in the basic composition with charcoal. Paint the background tree with French Ultramarine and Indian Yellow, thinned with plenty of medium to produce a glazed effect. Let your brush strokes show to give the impression of foliage. Mix Cobalt Blue, Lemon Yellow and a little Titanium White for the middle bushes and use the edge of the flat brush to create a spiky feel.

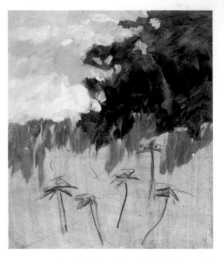

2 Next, paint the sky, using Cobalt Blue and Titanium White. Add more Titanium White towards the horizon to create a sense of recession. Use Cobalt Blue, Burnt Sienna and Titanium White for the clouds, with impasto brush strokes of pure Titanium White for the fluffy tops. Keep your colours dry with no medium added and let your brush strokes stand out to give movement to the clouds.

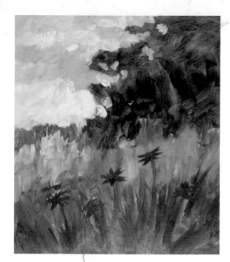

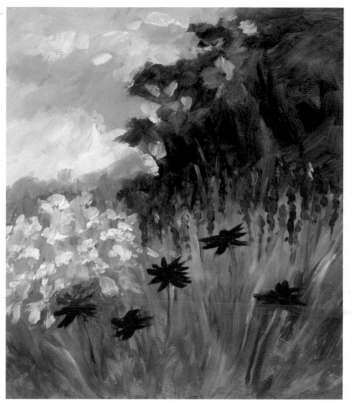

3 Finish blocking in the greens over the rest of the painting surface. Use the flat brush and a mix of Lemon Yellow and Cobalt Blue in the middle distance, adding a warmer green of Indian Yellow and Cobalt Blue for the foreground grasses. Next, use the round brush with pure Permanent Rose (no medium) to paint the foreground flower heads, adding stems with Raw Umber.

4 Use the round brush and a mix of Cobalt Blue, Permanent Rose and Titanium White for the flowers on the right, painting several lines of dots to give the impression of tall flower spikes. Clusters of Titanium White impasto marks are ideal for the larger flower heads on the left-hand shrub. Finally, add centres to the red flowers, using Raw Umber, before blending lines of darker green to suggest the tall grasses in the foreground.

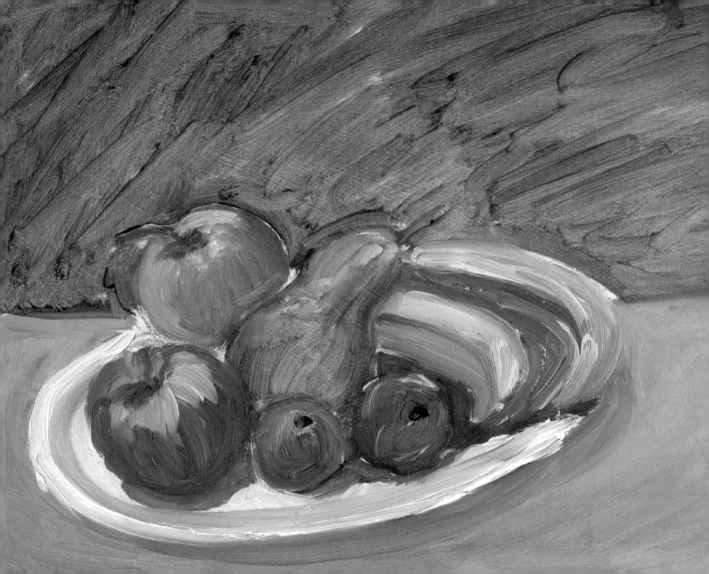

QUICK STUDIES

Making quick studies of individual subjects is an excellent way to learn, as it enables you to concentrate on one aspect at a time. Each section in this chapter looks at a different subject, including many of those that you might want to incorporate into your more finished or complex paintings – for example, familiar objects, landscape features, buildings, water, skies, boats, animals and people.

Take your time and enjoy the learning process. You will be surprised at just how delightful these quick studies can be and they will provide an invaluable source of reference for future paintings.

◀ **Fruit Bowl**
25.5 × 30.5 cm
(10 × 12 in)
The brush strokes on the fruit are clearly visible here and help to define their shapes.

Familiar objects

If you look around your home you will find that there is plenty to paint right on your doorstep. Start by picking just a few simple shapes – a jug or vase, some fruit, even a kitchen chair. Now look carefully at your chosen subject and ask yourself some questions. What is its overall shape? Where does the light fall? Is it casting a shadow? Make a simple drawing before you start to paint. Then look to see which areas are in shadow and put these in first, before colouring the main part of your subject. Finally, use much thicker paint with no medium for the highlights.

Garden items also make wonderful subjects to paint – flowerpots, tools, an old watering can or a hose, for example. Rather than trying to paint the whole garden, concentrate on just a few details such as these.

▶ **Studio Materials**
A simple subject such as these bottles of painting medium and a painting knife made an ideal quick studio study.

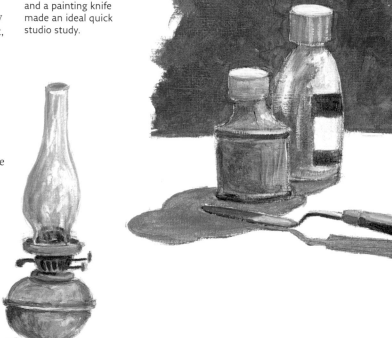

▶ **Oil Lamp**
I love old oil lamps. Using Raw Sienna and Titanium White with just a little Naples Yellow helped me to capture the sunlight glinting off the brass base.

QUICK TIP

Check that your shadows accurately indicate where light falls on the object that you are painting.

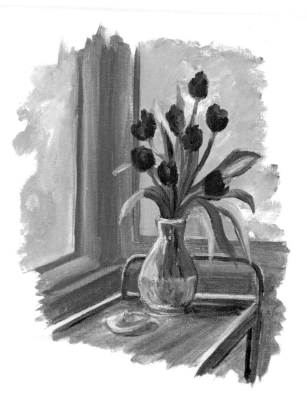

▶ **Tulips**
These tulips in my studio window made a lovely subject. The red flowers contrast sharply with the neutral greys of the glass and window frame behind.

▼ **Garden Still Life**
This watering can was sitting outside my window. I mixed Coeruleum, Cadmium Red Light and Titanium White for the silver-grey shades on the can.

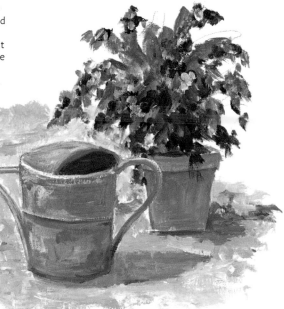

In the countryside

When you are outdoors it can be difficult to settle down to paint, even for 30 minutes, but this is where quick studies can help. Start by painting a single tree or a close-up of a gate. This will give you time to concentrate on the shape, colour and shadows, rather than trying to capture a whole scene at your first attempt. As you become more confident painting these single-subject studies, move on to simplified views, perhaps a cornfield with poppies waving in the breeze, a bluebell wood, or a country lane. The key to these quick landscape-based studies is not to paint 'the world', but just a small corner of it.

▶ **Winter Tree**
21.5 × 16.5 cm
(8½ × 6½ in)
I mixed Burnt Sienna with French Ultramarine for the dark browns of the main trunk and branches, before adding the outer twigs with dry brush strokes of dark purple. The shadows in the snowy lane were put in with single sweeps of paler purple.

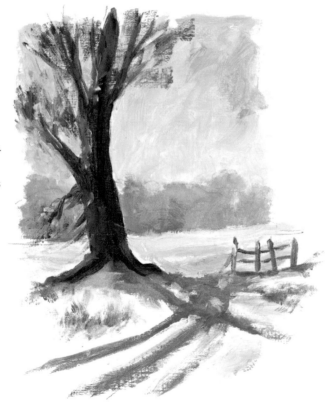

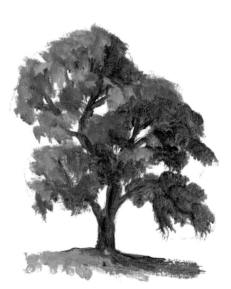

▲ **Summer Tree**
This is made up of a series of shapes representing light and dark foliage, rather than being simply a mass of green. It is the contrast of light and dark that makes the tree appear three-dimensional.

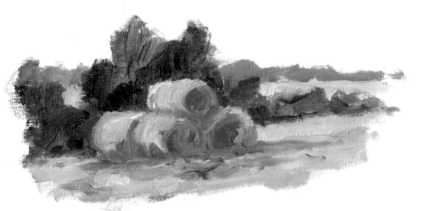

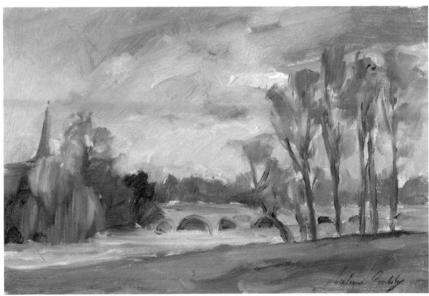

QUICK TIP

Paint distant greens much paler and bluer than they actually are to help them to recede into the background.

▲ **Haystacks**
Bales of hay make an interesting quick study. I liked the strong contrast of sunlit hay against the dark hedge behind.

▶ **Wallingford Bridge, Oxfordshire**
10 × 15 cm (4 × 6 in)
Even when painting a more complete scene, keep to a simple subject. Here just the church spire and bridge are enough to suggest the distant town.

Buildings

When painting buildings, start by thinking of each one as a combination of simple box shapes. This will help you to see them as simplified forms. Next, you will need to consider the matter of perspective. This can be a bit off-putting for the inexperienced painter, so if you find this tricky, the diagram below will help you to understand the basic principles.

A useful and effective way to include buildings in your paintings without having to worry too much about perspective is to paint them in silhouette. This is especially helpful when painting city scenes. First draw in the outline of the rooftops and then paint all the buildings using a single dark colour.

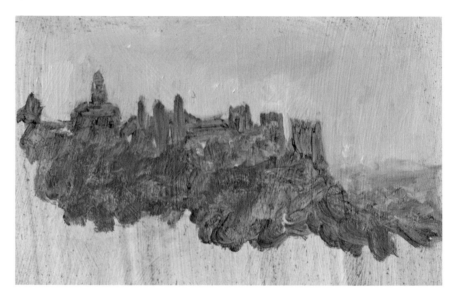

▲ **Palace of Granada**
The palace against the late afternoon sun made an interesting subject for this quick study. I used a mix of Raw Umber and Cobalt Blue for the silhouetted buildings, then added a little Raw Sienna for the foreground trees.

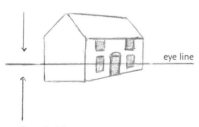

eye line

▲ All angled lines above the eye line travel down towards it, whereas lines below the eye line go up towards it.

Building details

Doorways and windows make great subjects for quick studies. Even when painting them close up there is no need to put in every brick or window frame. A few lines and the odd brick will be enough, allowing the viewer to imagine the rest.

When painting brick details, apply single horizontal brush strokes directly on top of the wet colour used for the building. Using medium pressure on your brush will help these marks to blend into the underlying colour to suggest the bricks in the wall.

▼ The Blue Door
Texture on the door was achieved by painting the shadows, rather than too much detail. Shadows also give shape and form to the stone steps.

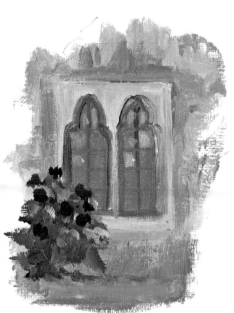

◀ Cottage Window
This lovely old window in a stone cottage attracted my eye. I used smooth brush strokes for the inner stone frame, contrasting these with shorter brush strokes and impasto to suggest the rougher stonework of the main wall.

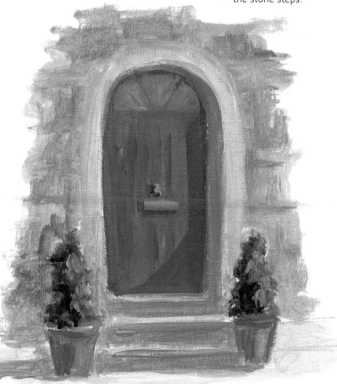

Water

Oils are the perfect medium for painting water. Colours can be softly blended together to create smooth, mirror-like reflections in still water. Thick impasto brush strokes on top of darker colour are ideal for portraying sparkling light on open water or fast-moving water, such as in a fountain or waterfall. When using impasto marks in this way, take care to apply light pressure on your brush so that the colours do not blend together. Because oil paint remains wet for some time, mistakes can always be wiped off or changed as you wish.

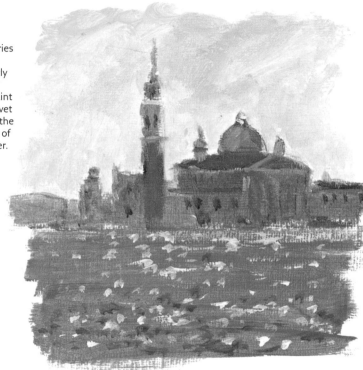

▶ **Venice**
11 × 11 cm
(4¼ × 4¼ in)
Here I used a series of short brush strokes and gently overlaid blobs of thick impasto paint on to a layer of wet colour to create the sparkling effects of light on the water.

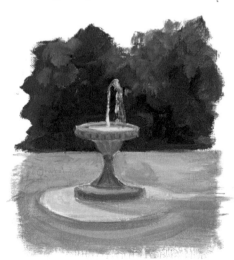

◀ **Garden Fountain**
I mixed a little Coeruleum with Titanium White for the fountain and painted the water in the direction that it was moving. The falling water contrasts well with the dark-green hedge behind.

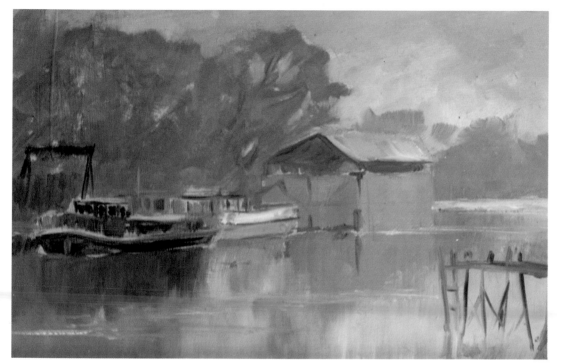

◀ **Grey Day, Isleworth**
25.5 × 30.5 cm
(10 × 12 in)
I used softly blended vertical brush strokes to paint the water, making sure that the depth of the reflections matched the actual sizes of the buildings and boats.

Painting reflections

Mirror-like reflections are easy to achieve with oils. Paint them with a No. 7 long flat brush, using soft vertical brush strokes to blend each colour into the next. Where reflections are more distorted a different technique is required. First paint the water as a flat area of colour and then add the reflections with a No. 4 round brush, using a series of short horizontal brush strokes to create a broken effect. If you find this difficult to achieve at first, simply re-blend the wet surface with the flat brush and try adding the reflections again.

QUICK TIP

When painting flowing water, make sure that your brush strokes follow the direction of movement.

Skies

Skies make wonderful subjects for quick studies in oils. Add a distant hillside or a strip of water along the horizon and you have all the elements you need for a simple painting.

It is important to decide on the 'mother colour' for your sky before you start your painting. This is the main blue to be used both for clear areas of sky and to mix the grey shades for the clouds; by using the same blue throughout, you will create harmony in your sky, as all the colours will relate to each other. When adding a landscape below, use the same blue again for mixing your greens so that the sky and landscape will harmonize effectively.

Perspective in skies

Remember that there is perspective in skies just as there is in the landscape. Clouds appear larger the nearer they are to the viewer, so paint the biggest ones at the top of your painting, gradually decreasing their size towards the horizon.

Similarly, when painting a clear blue sky, keep the strongest blues towards the top of your picture. Gradually add white to your mix to make first a paler blue for the middle section and then cream (or pink for a sunset) as the sky dips towards the horizon. This will help to create depth in your painting.

▶ To make grey shades suitable for painting clouds, mix blue, orange and white, as shown here. See how many different greys you can make.

▼ Sunset

10 × 15 cm (4 × 6 in)
Here I painted the sky first, using Indian Yellow and Cadmium Red Light for the sunlit edges to the clouds. I put in the sun as a pale gold disc and added the same colour to a few ripples in the water and to the beach.

Coeruleum +
Cadmium Red Light +
Titanium White

French Ultramarine +
Cadmium Red Light +
Titanium White

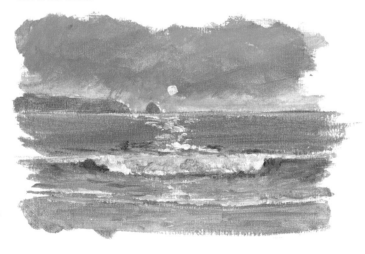

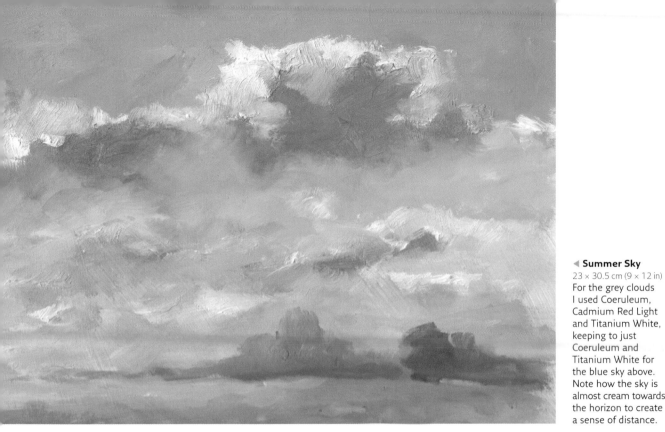

◀ **Summer Sky**
23 × 30.5 cm (9 × 12 in)
For the grey clouds
I used Coeruleum,
Cadmium Red Light
and Titanium White,
keeping to just
Coeruleum and
Titanium White for
the blue sky above.
Note how the sky is
almost cream towards
the horizon to create
a sense of distance.

QUICK TIP

Remember to use softened edges
for clouds so that they become
part of the sky, not simply stuck
on top of it.

Boats

Boats are an essential part of the scene in seascapes, coastal and river views, but you do not need to be an expert on boats to paint them. As for buildings, boats tend to be made up of several simple shapes, usually a series of rectangles with an angled shape for the bow. Cabins are generally fairly square. Look first at the main shape of the hull before adding a cabin or mast on top. When working quickly you may find it easier to paint a series of solid shapes with a brush, rather than drawing an initial outline in pencil.

▶ Cornish Fishing Smack
Even if you are painting from a photograph, aim to keep details of the rigging to a minimum – just a few carefully placed lines will suggest this. Here the angle of the figure steering the boat provides a strong sense of movement.

▼ Motor Boat
The figure in this 1950s' motor boat adds scale, whilst the bow wave helps to indicate movement. There was no need to paint the sky – a few brush strokes for the water were enough for a quick study such as this.

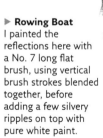

▶ Rowing Boat
I painted the reflections here with a No. 7 long flat brush, using vertical brush strokes blended together, before adding a few silvery ripples on top with pure white paint.

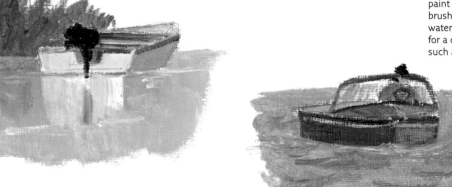

Scale and proportion

The key to painting boats in your scenes is to get the scale right. As you paint, keep checking that your boat is in proportion to, say, the figure on the bank or the buildings in the harbour. If, when you are working on your picture, a figure walks by, mark in the head height as he or she goes past the boat you are painting – a quick dot of paint for the head and a brush stroke for the torso will be enough. Then add the legs and arms, and your figure will be complete almost as quickly as they have walked out of view!

▶ **River Cruiser**
Details such as the blue fenders and the cabin windows help to create the shape and form of this cruiser on the River Thames.

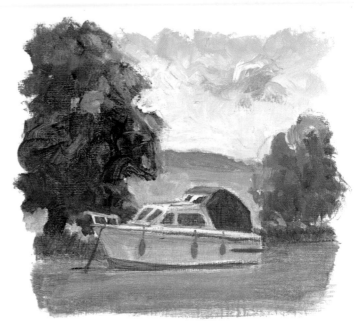

▶ **Narrow Boat**
This traditional narrow boat was moored up, which gave me plenty of time to paint it. I added the figure later when he came back to take the boat away.

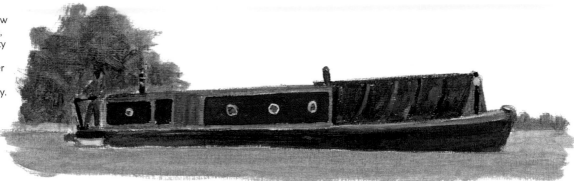

Animals

Including animals in your paintings is a good way of introducing a sense of life and movement. A simple sketch of a dog on the beach, for example, makes an excellent subject for a 30-minute painting. Learning how to paint animals by using simple shapes, rather than outlines, will help you to portray them quickly and easily.

Place your animals in the middle distance so that they appear part of the scene, rather than the main point of interest. Think also about scale: for example, even a large dog is rarely taller than an adult's knees. When painting a moving animal, leave out details such as paws and hooves as this will help to suggest a sense of movement.

Animals in the landscape

Sheep and horses often feature in landscape scenes. Practise drawing and painting simple studies of these so that you will be confident about adding them to your finished paintings. Sheep are more rounded than dogs so have a different underlying form. Make a few pencil sketches of their shapes before you try painting them. As your confidence grows, you will find yourself working directly in paint with no preliminary drawing at all.

▶ To sketch a dog, start with a rectangle for the body. A square and another rectangle make up the head, with the tail coming off the top of the back.

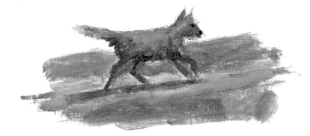

◀ **Running Dog**
I painted the whole dog with thinned Raw Umber first, then added Naples Yellow for the highlights. The angles of the legs, and lack of detail on the paws, indicate movement.

▶ To sketch a sheep, start with an oval for the body and another for the hind quarters, adding a triangle for the head.

▼ **Sheep Study**
I used Raw Sienna and Titanium White for the sunlit sheep, with Raw Umber and Coeruleum for the shadows.

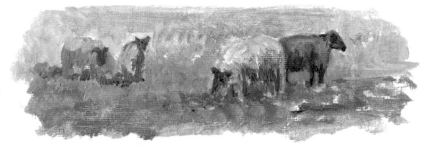

▶ Horses are fairly complex animals to paint, but this sketch shows how you can break down their overall shape into a series of ovals and circles for the body and leg joints.

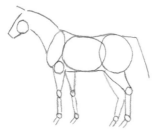

QUICK TIP

Photographs of animals can be a very useful reference tool, especially when it comes to capturing their movement.

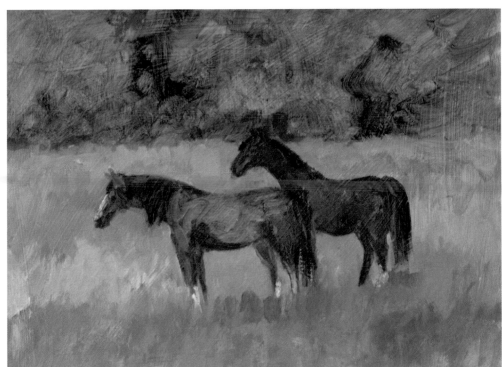

▶ **Watching Horses**
20 × 25.5 cm (8 × 10 in)
These horses stood still for at least 10 minutes, giving me time to paint them. I concentrated on just the animals, adding the background trees and grass after they had gone.

People

Like animals, people can be useful additions in a painting and they need not be complicated. A simple study without any facial details or a distant figure walking away from you are easy to paint, done with just a few quick brush strokes, and will add life and a sense of movement to the scene.

Keep your figures very simple. For a figure in the middle distance, start with a brush stroke in the shape of a carrot; this gives you the shoulders and one leg. Add a blob of paint for the head and a few brush strokes for the arms and second leg, and you have a simple figure. It really is that easy!

Getting the proportions right

Painting adults and children using these simple methods is fun, but it is important to ensure that you get the proportions of your figures correct. One point to remember is that children have different proportions from adults. Whilst an adult is generally eight heads high, a toddler may be only three heads high and an older child (say, around 8 or 9 years old) approximately six heads high. The actual size of children's heads is also slightly larger relative to their bodies. This subtle difference in head size will make your figures look more realistic.

◄ See how a carrot-shaped brush stroke develops into a distant walking figure when the head, arms and second leg are added with more brush strokes.

► Turn a series of coloured brush strokes (*left*) into a group of figures simply by adding heads and legs, and a few shadows.

► There is no need to paint faces on your figures; adding a few strokes of dark paint for hair over a flesh-coloured blob of paint for the head provides enough detail for these quick studies.

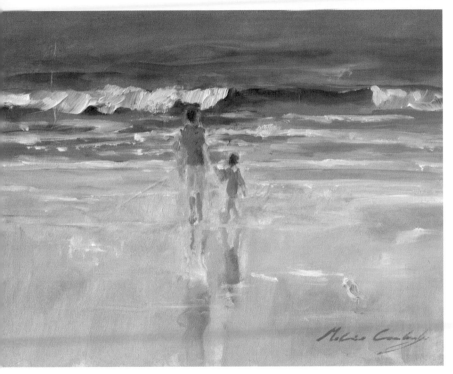

◄ **Dad and Me**
25.5 × 30.5 cm
(10 × 12 in)
See how the child's
head is proportionately
a little larger compared
to the adult's head.

QUICK OVERVIEW

☐ Practise painting just single subjects
or close-up views to begin with, to build
up your confidence.

☐ Simplify shapes wherever you can.

☐ Leave out unnecessary details and
backgrounds.

☐ Get to grips with the basics of
perspective when painting buildings.

☐ Use the same blue to mix sky greys
and landscape greens to create
harmony.

☐ Include animals in your paintings to
introduce a sense of life and movement.

☐ Always check that the proportions of
children and adults are correct.

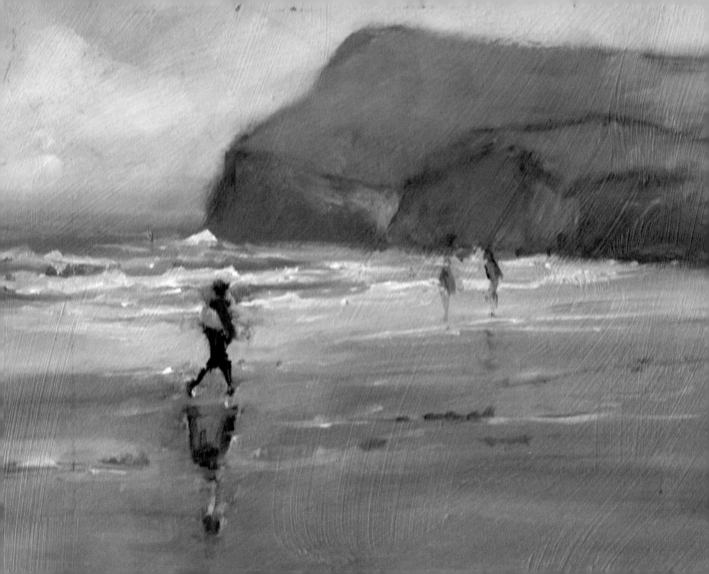

COMPOSING YOUR PICTURES

Composition provides the framework for your painting, leading viewers in and guiding them to the main point of interest. Even for 30-minute studies, good composition is important and will make your paintings stand out from the rest.

This chapter includes a number of guidelines about aspects of composition that will help you to achieve well-planned and successful paintings. These are not strict rules, but they will be very useful when you first start to paint, and with experience you will find that planning your painting effectively becomes second nature.

◄ **Yellow Surf Board**
20 × 25.5 cm (8 × 10 in)
I kept this composition simple to emphasize the deep reflections and strong colour in the sand. The foreground figure leads the viewer into the painting, whilst the cliffs act as a barrier to keep the eye on the beach.

Planning your paintings

Composition is simply the arrangement of shapes within a painting. When you are working outdoors, however, it can be difficult choosing what to include in your painting and what to leave out, especially if you do not have much time and are looking to simplify the scene in front of you. A viewfinder is very helpful in enabling you to identify potential subjects because, rather like looking through a camera lens, it lets you see only a small part of the whole scene.

Using a viewfinder

You can make your own viewfinder by cutting two 'L'-shaped pieces of cardboard which you then fit together to form a window the same shape as your painting surface. Hold the viewfinder at arm's length and use it to frame the subject in front of you. When you do not have a viewer with you, you will find that using your own hands works just as well for quick reference.

Using a viewfinder will also help you to avoid the 'curse of the moving eye line'. Make sure that you keep your head up and your eye level constant as you paint, otherwise you risk changing the horizon in your painting and warping the perspective. If you paint only what you can see through the viewfinder at arm's length, however, this will not happen.

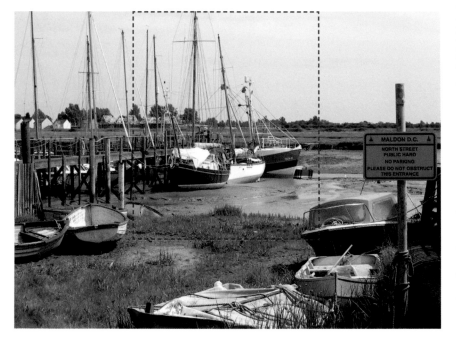

◀ **Maldon jetty**
This jetty has the potential to be an interesting subject. The overlaid lines show how a viewfinder could be used to help you to decide what to paint in a busy scene such as this.

Rule of thirds

Paintings with the horizon in the middle or the main point of interest dead centre tend to look rather uninteresting from a compositional point of view. Using a device known as the rule of thirds will help you to avoid this.

Start by dividing up your painting surface into thirds as I have done in the diagram below. This will give you four cross-points where the lines meet. Each of these intersections marks a good spot to place the main point of interest in your painting.

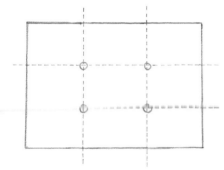

▲ The rule of thirds, showing the four cross-points, marked by small circles, which are all suitable places for the main point of interest in a painting.

Guiding the viewer's eye

A well-composed painting draws the viewer into the picture, encourages them to look around, and then guides their eye to the main point of interest. This is easier to achieve than it sounds. For example, a simple path through woodland could lead towards a figure in the middle distance or perhaps a river winding through meadows might direct the viewer's eye towards a church on the horizon.

▲ **Boats at Eling Mill**
20 × 35.5 cm (8 × 14 in)
Here the river leads the viewer into the painting towards the two figures on the bridge. The wooden post acts as a link between the water and the top of the bridge, whilst the red and blue boats echo the colours of the figures' jumpers.

Compositional shapes

To help you to establish an interesting composition for your paintings there are several standard compositional shapes that you might find useful. The first is a simple 'L' shape, in which a vertical feature forms a right angle with the horizontal elements of a painting.

Another popular compositional shape is the 'S' pattern, in which a lane or river is used to lead the eye of the viewer into the painting up towards the main point of interest.

The diagonal split can also be an effective compositional shape. This can be a particularly helpful tool when painting a beach scene as it is easy to

use foreground cliffs to create interesting diagonal shapes. In addition, lines of wet sand can be useful in leading the viewer's eye into a picture, so when painting at the seaside take a careful look around for such features before you choose your view. A few quick sketches such as those shown here will help you decide how to start.

▶ Here the 'L' is formed by the foreground tree and the horizon, which itself runs along the lower line of the rule-of-thirds grid. The main point of interest, the church, is placed at the lower right-hand cross-point.

▼ In this sketch the figure sitting on the rock at the bottom of the cliff is the main point of interest.

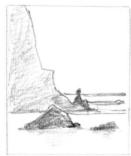

◀ Here an 'S' composition is created in this sketch of the river at Cuckmere Haven as it winds towards the sea near Eastbourne in East Sussex.

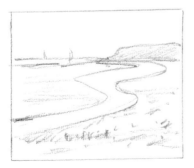

▲ **Evening Stroll, Polkerris, Cornwall**
25.5 × 20 cm (10 × 8 in)
I liked the diagonal composition of this scene, created by the dark rocks, and the strong contrast between them and the sparkling light on the sea gave the painting atmosphere.

Potential pitfalls

There are a few pitfalls you should try to avoid when you are first starting out. One trap that is easy to fall into is placing your point of interest right in the centre of your composition, which can look rather dull. If, for example, you want to include someone walking along a woodland path, try offsetting the figure and including slightly more trees on one side of the path than the other. In this way you will create a circular 'O'-shape composition, which will be more interesting to the viewer.

Another common mistake is to put a barrier across the front of your painting – a fence or hedge, for example. This cuts the painting in two and prevents the viewer looking into the middle distance. Put an open gate in the fence or leave a gap in the hedge, however, and the composition is restored.

Including two features of equal size in your painting, especially if they are on opposite sides of the picture, can also cause problems. The eye of the viewer will tend to flick from one side to the other, rather than being drawn to the focal point. If you take out one of the features and replace it with, say, three smaller ones in the middle distance the problem is solved.

▲ Here the fence acts as a barrier to the viewer.

▲ By adding a gate you can lead the viewer into the picture.

▲ This composition is too symmetrical. The viewer's eye flicks from one tree to the other.

▲ By replacing the tree on the left with a smaller group the composition is improved.

QUICK OVERVIEW

☐ Use a viewfinder to help you to choose a good composition.

☐ Place the centre of interest in your painting according to the rule of thirds.

☐ Plan a route through your painting to the main point of interest.

☐ Make quick tonal studies to explore different compositional shapes.

Planning your paintings

Understanding the basics of composition and how to use this knowledge to help you to plan your paintings successfully are key skills for the aspiring artist. This project shows you how to be selective when working from photographs and how to use them to create great paintings.

Working with photographs
Find several photographs of landscapes and lay them out in front of you. Look carefully at each photograph to find at least one compositional shape within it that you could use in a painting. Then make quick tonal studies to cement your ideas before choosing one to use as the basis for your painting.

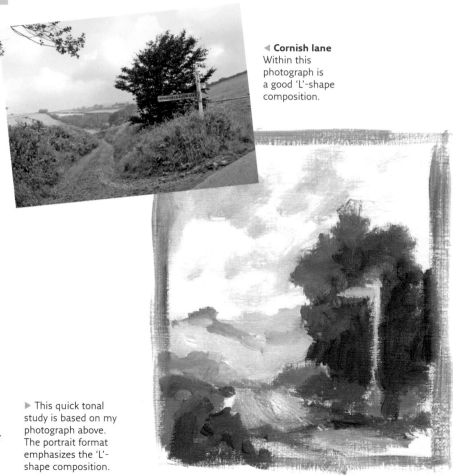

◀ **Cornish lane**
Within this photograph is a good 'L'-shape composition.

▶ This quick tonal study is based on my photograph above. The portrait format emphasizes the 'L'-shape composition.

Different viewpoints

Looking at a subject from different angles will give you the potential for several paintings. You can try this exercise by either setting up a simple still life subject and making a series of quick sketches from different viewpoints or by working from photographs as I have done here. Whenever you visit a new location, especially if there will not be time even for a quick sketch, do not forget your camera. Take a series of photographs from different angles of any subjects you spot so that when you return home you will have a selection of ideas to work from.

▶ **On the Beach, West Wittering**
30.5 × 25.5 cm
(12 × 10 in)
I used the second photograph as the basis for this painting. Shadows cast by the foreground posts emphasize the 'S'-shape composition and lead the viewer's eye towards the figures and dog.

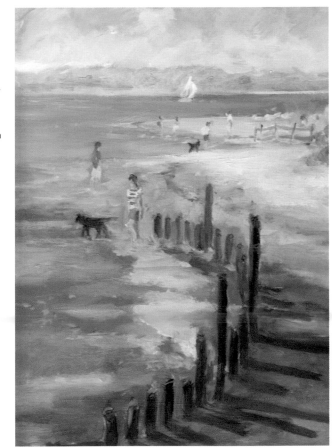

▼ **West Wittering beach 1**
A typical photograph of the beach, taken whilst out with friends. It is a nice shot, but it offers nothing obvious to guide the viewer's eye into the scene.

◀ **West Wittering beach 2**
By moving my position slightly and changing to a portrait format, I was able to use the row of posts in the foreground to lead the viewer's eye into the middle of the beach, improving the composition considerably.

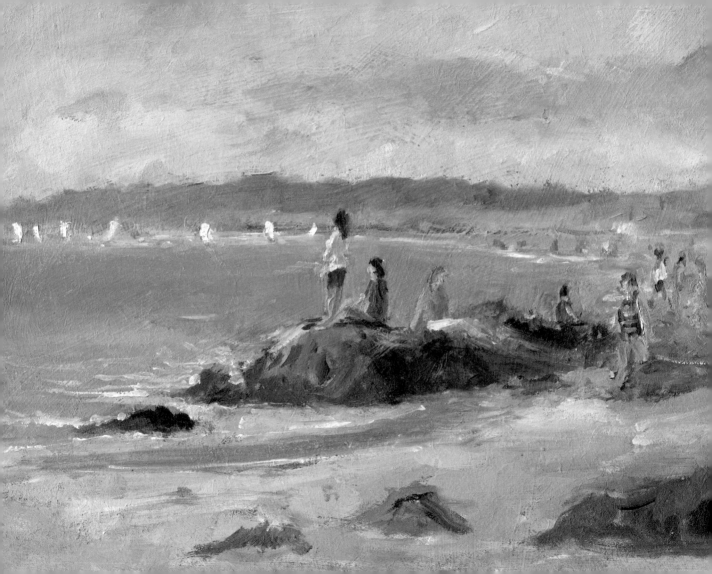

CHOOSING A SUBJECT

Deciding what to paint can be tricky, especially when you have limited time available, as there is so much to choose from. The secret is to keep things simple when choosing your subject, and to look for the uncomplicated view or close-up corner, rather than trying to paint everything you can see.

In this chapter I have selected various subjects and tried to give you ideas as to how you might approach them when painting quickly, whilst still capturing the essence of the subject in just a few brush strokes. This takes practice, but the results are well worth it.

◀ **Watching the Racing**
20 × 25.5 cm (8 × 10 in)
As the people here gathered to watch a local dinghy race in Sweden they stayed relatively still, giving me time to paint them as they sat in groups on the rocks and along the foreshore.

Landscapes

When painting wide open landscapes you will need to simplify much of what you see. For example, distant hedgerows can be stated with a single line of paint and fields can be suggested with simple brush strokes and blobs of colour.

Detail and colour fade considerably towards the horizon, so make your colours not only paler but also bluer as you paint features in the distance. It helps if you can imagine the view on a misty day when much of the distant colour and detail is blocked out – this is the effect you are trying to portray.

Remember that warm colours, such as reds and oranges, tend to come forward when seen alongside cooler blues and greens, so use these colours sparingly and only in the foreground. Think also about scale. Trees appear large in the foreground with all their branches clearly defined, whereas even in the middle distance they will be much smaller, with perhaps only the main trunk visible below the foliage. Look carefully at the landscape in front of you before you start and paint only what you can see, not the details you know are there.

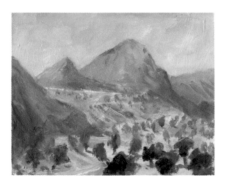

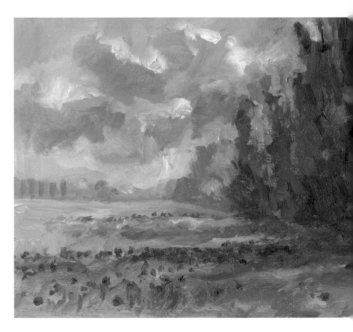

◄ **Mountain Pass, Andalusia**
20 × 25.5 cm (8 × 10 in)
This complex view was painted very simply on a yellow-tinted board. Only the foreground olive trees have trunks and shadows to create a sense of scale and distance.

▶ **Summer Poppies**
20 × 25.5 cm (8 × 10 in)
The poppies here are simple blobs of bright red in the sunshine, but darker red in the shadows, and I painted the centres in only a few flowers in the foreground. I kept the strongest greens for the nearest trees.

QUICK TIP

Take out extra details to simplify a scene and do not add anything that is not already there.

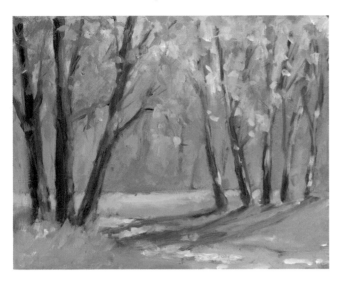

◀ Spring Woodland
20 × 25.5 cm (8 × 10 in)
I used plenty of softer greys and purples when mixing the colours for the trees in the background, reserving the brighter spring greens for the foreground foliage.

▼ A Favourite Spot
20 × 25.5 cm (8 × 10 in)
I harmonized the various greens in this painting by using Coeruleum throughout, changing only the yellow in the mix. Lemon Yellow was used for the background trees and Indian Yellow for the middle section and the foreground.

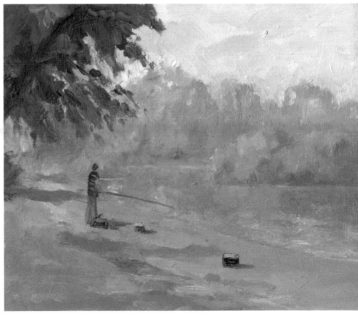

Canals and rivers

Canals and rivers provide plenty of fascinating subjects to paint. Boats may be moored up along the bank, giving you time to observe them closely and paint them. Lock cottages with their pretty gardens add much colour to the waterways and are lovely to paint. There are usually people walking along the towpath or riverbank to sketch, and lots of ducks and birds to include as well. Finally, there are many opportunities to paint both wonderful reflections and faster-moving water over weirs and near locks.

Painting indoors

When time is limited there is no need to go outside to find a subject to paint. Your home is a collection of ready-made views and scenes – a corner of the sitting room; a view through a doorway into the garden beyond; or even a lamp on the hallway table. This project will encourage you to see what is on your doorstep.

Finding a subject

Take time to look around – you will be surprised to find plenty of simple scenes to paint without ever having to step outside your front door. Use a viewfinder to seek out subjects – a collection of plates on a kitchen dresser perhaps, or

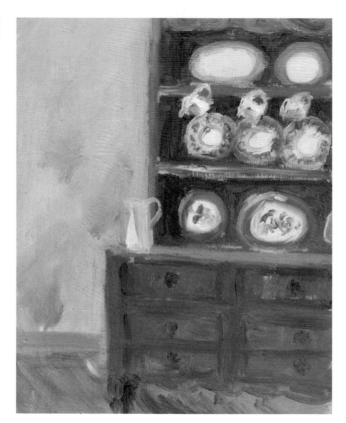

◀ **Kitchen Dresser**
25.5 × 20 cm (10 × 8 in)
This was painted on a board tinted with Raw Sienna and this background colour shows through, adding depth to this quick study.

a glimpse into a bedroom through a half-open door. Look for corners where the light falls on some areas but leaves others in shade, as this will help to create a more interesting painting.

Making a start

Once you have chosen a subject, sketch in the main shapes. Take care to look at the relative scale of different items – those which are twice the distance from your eye will appear half the size, making a chair in the foreground, for example, seem much larger than you first thought. When you are happy that the main features relate to each other correctly, pick up your brushes and get painting.

Make several 30-minute paintings around your home – try to find a subject in each room. Add variety and interest to each painting by varying the format: try a square shape in the dining room, a tall thin shape for the bedroom doorway or a long horizontal shape in the kitchen. Have fun wandering around with a viewfinder, discovering new challenges in every corner!

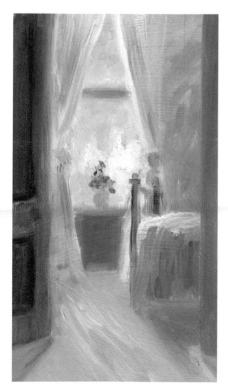

◀ **Through the Bedroom Door**
23 × 13 cm (9 × 5 in)
Doorways make interesting subjects and are especially well suited to a tall format.

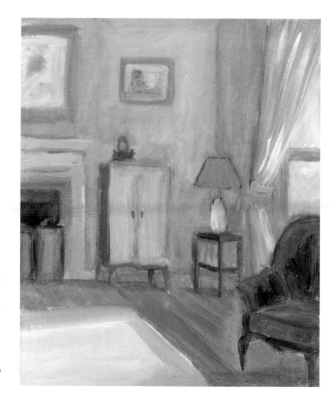

▶ **The Sitting Room**
25.5 × 20 cm (10 × 8 in)
Here I sat on one side of the room and painted the items in the opposite corner. See how large the foreground chair appears compared to the table and lamp.

Townscapes

When you are painting in a town, buildings rather than hills or trees will usually form the background, as well as perhaps being the main focus of your painting. In such cases, leave out much of the detail; paint them with a number of tonal brush strokes to form a simple background pattern.

Architectural details can be a bit daunting at first and may seem far too complicated for a 30-minute painting. However, by simplifying what you see and keeping more ornate buildings towards the background of your picture it is possible to paint them within this short timescale. I often portray such subjects against the light when details are lost; the key to capturing the scene is to paint the silhouette accurately, rather than the intricacies of the architecture. This approach generally results in far more atmospheric paintings.

Streets are rarely deserted, so do include a few figures, lamp posts and even the odd car or bus in your townscapes where appropriate.

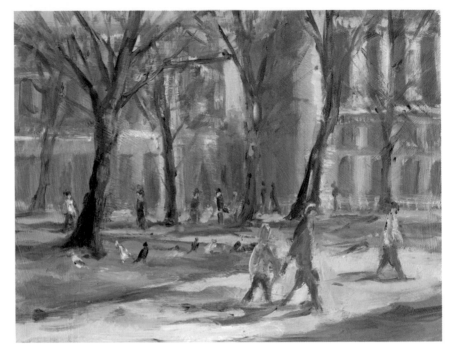

▲ **A Walk in the Park, London**
20 × 25.5 cm (8 × 10 in)
For the background buildings I used neutral tones and limited the amount of architectural detail, painting the windows and doorways with single brush strokes.

▶ This detail from *A Walk in the Park, London* shows the columns on the buildings, which were painted loosely with Naples Yellow and purple mixed from Cobalt Blue and Permanent Rose.

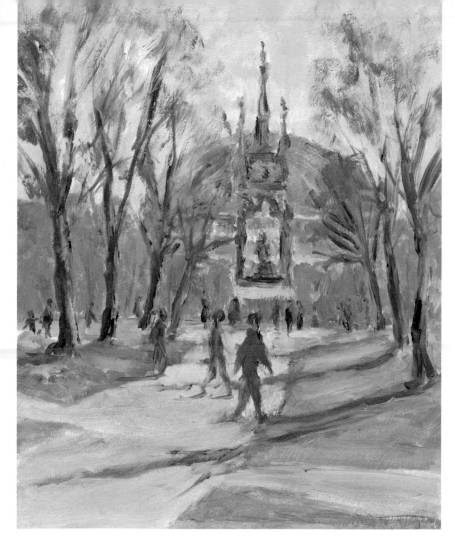

Take care to ensure that the figures in your townscapes are in proportion to any adjacent doorways and windows.

◀ **Winter Light, Hyde Park, London**
25.5 × 20 cm (10 × 8 in)
The splendour of the Albert Memorial, with the Albert Hall behind, was captured using soft grey shades and a minimum of architectural detail. The figures provide a sense of scale, leading the viewer towards the distant monument.

Harbours

Harbours are great places to paint, but do remember to check the tide before you start – a falling tide is certainly the safest. Boats that are settled on the sand are often at interesting angles, and being stationary are easier to paint than when bobbing around on the water in the breeze. Ropes, lobster pots and mooring buoys all add to the general clutter often found in harbours, so whenever possible try to include items such as these in your paintings.

Simplifying the scene

Harbours are usually busy places, so choose just one or two boats and concentrate on painting them, ignoring any others. Keep the background simple and paint just the harbour wall or cliff, rather than the entire fishing village or harbour buildings. In 30 minutes this is likely to be all you have time for and you will probably make a better composition than if you try to put everything into one painting. You can easily do a second painting if you have more time to spare.

◀ **Loading Up, Poole Harbour**
15 × 20 cm (6 × 8 in)
Sitting on the quay in Poole, Dorset, whilst friends popped off for coffee gave me enough time for this loose study of a boat loading up at the dockside opposite.

▶ **Polkerris Harbour, Cornwall**
15 × 20 cm (6 × 8 in)
Looking down from the cliff top gives a different perspective on this tiny harbour.

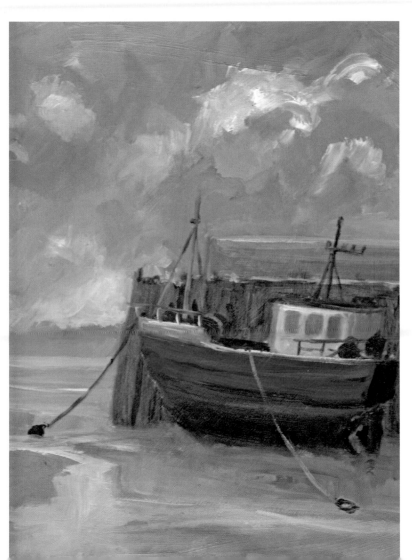

◀ **Waiting for the Tide**
30.5 × 25.5 cm
(12 × 10 in)
Here the harbour wall was painted with thinned translucent darks, which complement the lively brushwork used for the sky and harbour mud. A single fishing boat was enough to set the scene.

QUICK OVERVIEW

☐ Look for simple views or close-up details, rather than trying to paint a whole scene or complicated subject.

☐ Simplify your subject and paint only what you can see, not what you know is there.

☐ Keep colours in the background cooler and use warmer ones in the foreground.

☐ Painting buildings in silhouette is a useful way of simplifying them without losing atmosphere.

☐ Keep backgrounds simple in busy harbour scenes but include foreground detail.

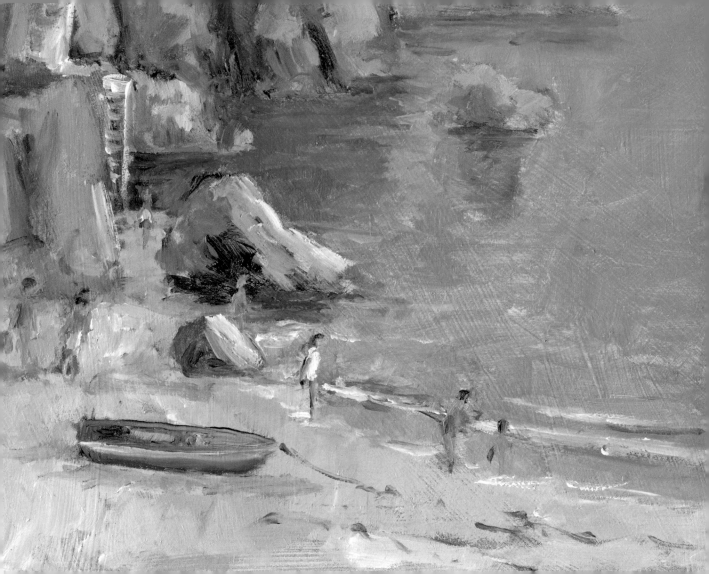

PAINTING ON HOLIDAY

Paintings and quick studies produced whilst on holiday hold special memories much more effectively than photographs. Sitting down to paint for 30 minutes enables you to take in the atmosphere of the place, enjoy the challenge of new subjects, and notice the colours and different quality of the light.

By all means take photographs as well if you wish as these can provide valuable reference for when you get home, but wherever possible try to sketch or paint on holiday as this is by far the best way to preserve those precious memories.

◀ **Nerja Beach, Spain**
20 × 25.5 cm (8 × 10 in)
I used my pochade box to paint this, whilst sitting on the Balcon de Europe where I was able to look down to the beach below. This gave an interesting, alternative viewpoint.

Practical considerations

A little forward planning before you leave home for a painting break, holiday abroad or even just a day trip can help to make it a most rewarding and enjoyable experience.

Most important, of course, are the materials that you take with you. When you are working outdoors, a painting surface tinted with Raw Sienna or a soft grey tone makes it easier to judge both lights and darks straightaway. Pre-tint enough canvases or boards for the whole trip with thin washes of colour a few days in advance so that they will be fully dry when you travel. Last thing before you go, double-check that you have everything you need for the entire trip; nothing is more frustrating than arriving in a new country to discover that you have left your favourite brush at home.

Essential materials

Unless you will have close access to a car, aim to pack only the absolute essentials. A pochade box is ideal for quick studies on location. I carry mine in a small rucksack, along with the other items in my outdoor kit. I use alkyd oil paints when I am travelling because they are non-flammable and dry overnight,

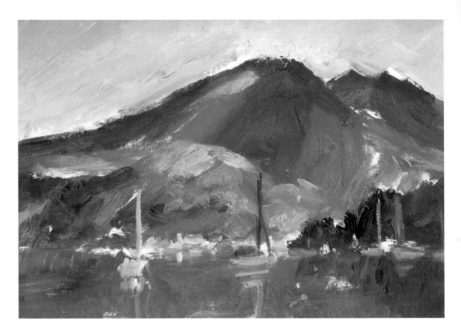

making it easy to take paintings home at the end of the holiday. I also take with me a small bottle of Liquin medium and a tub of soap brush cleaner.

For times when carrying a rucksack is not possible, make sure that you have a pocket-sized sketchbook and pencil or pen with you all the time, so that you can make quick drawings whenever you have a few spare moments – for example, when waiting for a ferry or enjoying a coffee in the town square.

▲ **Nidri Sunrise, Greece**
11.5 × 15 cm (4½ × 6 in)
I took a short walk near our hotel before breakfast one morning to watch the sunrise. Sitting on the jetty there was just time to paint these lovely purple and gold shadows before the sun rose and flooded the scene with light.

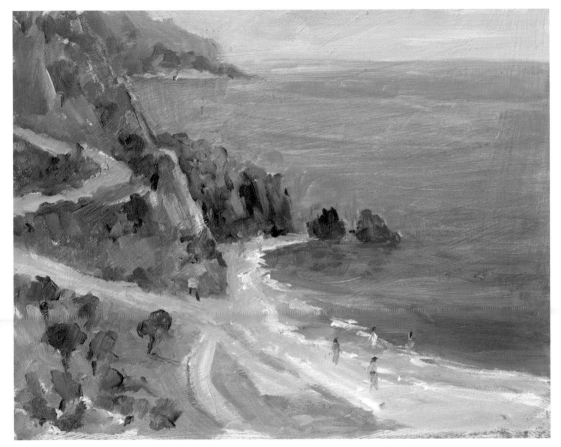

◀ **Spanish Coast**
20 × 25.5 cm (8 × 10 in)
This cliff-top view
made an interesting
subject. The figures
add a sense of scale,
whilst the road down
to the beach helps
to guide the viewer's
eye into the centre
of the painting.

Painting in busy places

Town squares, cafés and busy harbours all make fascinating subjects, but can be daunting places to paint. To avoid interruptions from curious onlookers, seek out a spot where you can sit or stand with your back against a wall or a quiet corner away from passers-by. Even in such busy locations people tend to ignore you, especially if you are sitting down, as they walk past looking straight ahead. If you still seem to attract too much interest, however, simply saying 'Excuse me, but I need to concentrate on this bit' usually discourages any further questions.

▶ **Capri Street**
15 × 10 cm (6 × 4 in)
You can see from the photograph below how details have been simplified and just a few loosely painted figures added to provide life and movement.

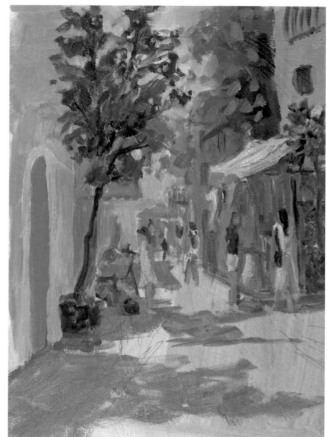

▶ **Shopping street in Capri**
I took this shot of a busy street while I was on holiday in Capri.

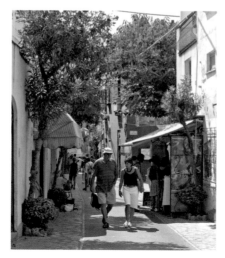

Sightseeing

Sightseeing trips can provide great opportunities to paint, but popular venues do tend to attract large crowds. When you first arrive, spend a little time people-watching before you start painting. This will help you to see where groups congregate before heading off around the sights, giving you time then for a quick study before the next group arrives.

Figures in local costume, a colourful market or town square often capture the essence of a foreign location better than the well-known sights, so look around to see what catches your eye, rather than always painting the famous view that everyone has come to see.

Look for a spot in the shade to avoid getting sunburnt while you work. If it is really hot, remember to wear a hat, and if the light is very bright sunglasses as well. You should have no problems painting while wearing sunglasses provided you keep them all the time while you mix and apply your colours; this will enable you to judge colour and tone under the same conditions.

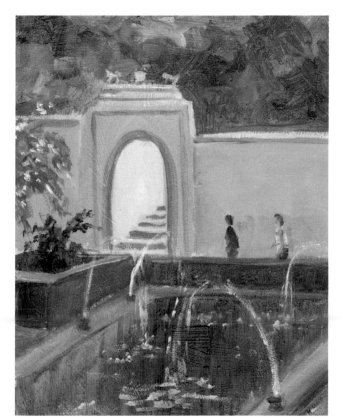

◀ **In the Gardens of the Alhambra Palace**
25.5 × 20 cm (10 × 8 in)
In this shady spot in the gardens the sunlight on the steps contrasted nicely with the deep shadows in the pool.

At the beach

Beaches are amongst my favourite places to paint. With light shimmering off the sea, reflections in wet sand, brightly coloured windbreaks, figures moving around, and sometimes steep cliffs or rock pools, there are always lots of subjects to choose from. Even if you are with a group of non-painters, it is easy to find time to paint on the beach as all most people want to do is sit and relax.

Gathering reference material

If you wish to collect reference material for your paintings, please take care when using a camera on the beach, particularly if you want to photograph children or family groups. Always ask permission first. I find it far preferable to paint or sketch at the beach as this does not raise the same concern from parents, especially when they can see that you are painting just figures, not specific faces.

◄ **Boy with Bucket**
This young boy kept carrying water from the sea to his sand castle, giving me plenty of time to paint him.

▶ **Old Harry Rocks, Swanage**
10 × 15 cm (4 × 6 in)
This was painted on a board tinted with Raw Sienna. Only the outline shapes of the cliffs were drawn with a pencil; brush strokes describe the surface, using a mix of Naples Yellow, Coeruleum and Titanium White.

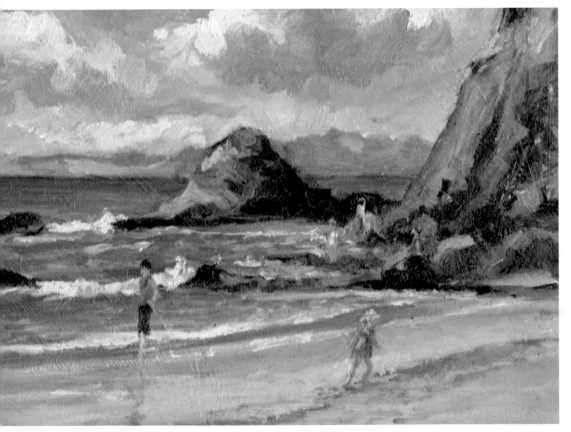

◄ **High Summer, Polkerris**

25.5 × 35.5 cm
(10 × 14 in)
Broad brush strokes give strength and texture to the cliffs. The little girl ran up and down to the water, providing me with an ideal opportunity to paint her.

In the mountains

Visiting any mountain location offers a wealth of subjects to paint, from soaring peaks to cattle and old farm buildings in the valleys below. In summer flowers cover the high meadows, making wonderful subjects for quick paintings.

A skiing trip might seem an unlikely holiday for painting, but there is often time in the late afternoon to sit in a café or on the hotel or apartment balcony for a 30-minute study before dinner. Light in the mountains can be spectacular, especially in the evening as the sun slowly sinks below the highest peaks.

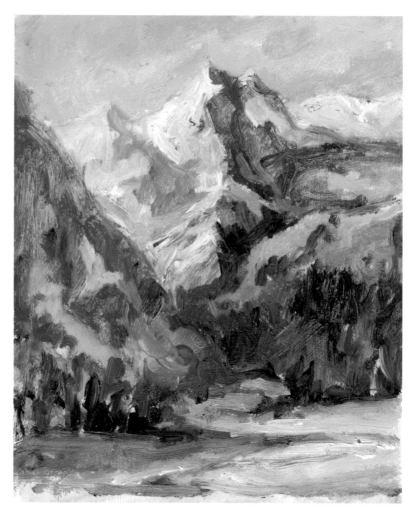

▶ **Late Afternoon Sun, Valloire, France**
25.5 × 20 cm (10 × 8 in)
This was painted from the window of our apartment in Valloire. I loved the golden light on the distant mountain, so concentrated on this and left out some buildings that were in the foreground.

Moving figures

Having finished skiing early one day, I returned to the top of the gondola station with my rucksack and pochade box with a view to making a painting. I watched several groups of schoolchildren as they finished their ski lessons. The instructors in each group whizzed past, but the young children were slow enough for me to mark in their arms and legs as they struggled to catch up with them. By observing several groups as they skied by, I was able to paint a quick study, partly from memory and partly by marking in the shapes of the figures with a few quick brush strokes.

This approach can be used to paint any moving figures – perhaps a group of walkers or climbers in the hills, for example, or children cycling or learning to ride horses. It does require a degree of confidence and speed, but is fun to do. Try it for yourself and see just what you can achieve.

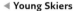 **Young Skiers**
10 × 15 cm (4 × 6 in)
I watched these figures first, then marked in the positions of their bodies, arms and legs, before finally adding the colours of the ski jackets.

QUICK TIP

To capture the strength of a mountain, concentrate on the main areas of light and shade. Adding too much detail may weaken the overall effect.

How to use photographs

When time is too short even for a sketch, photographs will at least capture the scene, but do take several shots from different viewpoints, as well as some close-ups of any details, figures or other points of interest. This will give you a selection of images to work from when you get home – the next best thing to a location sketch or painting. However, please do not rely on photographs for colour accuracy; the camera can distort colours, making distant greens appear much darker than they actually are. When using landscape photographs as your starting point, tone down any distant hills by painting them with more blue and less detail than can be seen in the photograph.

Making reference sketches

When you return from your holiday, look carefully at all the photographs you have taken. Make a series of quick tonal sketches based on those you feel could be used to make a painting, as well as a few colour notes. Refer to these sketches as you start to paint, so that you can concentrate on the main shapes and tones, rather than slavishly copying every detail in the photographs.

▲ **Canal barge 1**
This photograph was taken as a compositional shot as we cruised past a laden barge whilst on a boat trip.

◄ **Canal barge 2**
As we came past the barge, I took a second shot of the rudder detail to provide information for a later painting.

▶ I made this quick tonal study, based on the main photograph, to establish the best composition. The bridge has been moved and a gap left between the foliage for the sky.

▼ Nerja, Spain
This photograph has good potential for a painting but is a bit fussy, with too many rocks acting as a barrier across the foreground.

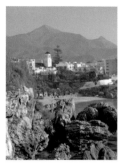

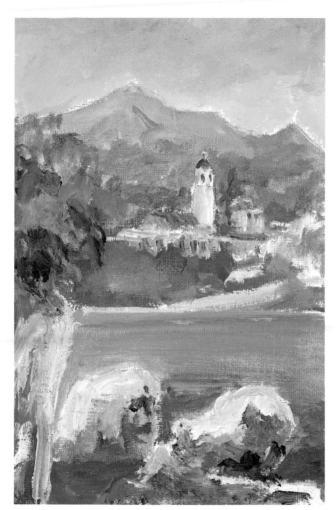

QUICK OVERVIEW

☐ Pre-tint painting boards in advance and take only essential materials away with you.

☐ A pochade box and small rucksack are preferable for sightseeing trips.

☐ Look for a quiet spot when painting on location to avoid being interrupted.

☐ Use your holiday paintings to capture the atmosphere of a place, rather than every detail.

☐ A camera is a useful tool for gathering information and recording details.

◄ View of Nerja Church
20 × 14 cm (8 × 5½ in)
For this study the buildings in the middle distance were painted loosely; only the church has any recognizable details. Leaving out some of the foreground rocks encourages the viewer to look towards the main centre of interest.

Painting on holiday

Whether working on location or painting from holiday photographs, keeping your brush strokes lively when portraying texture in both rocks and surf is the key to painting them well. Try to paint as freely as you can and let your brush strokes do the talking!

MATERIALS USED
No. 7 long flat brush
No. 4 round brush
Stretched canvas,
 tinted with Raw
 Sienna
Charcoal
Alkyd medium
French Ultramarine
Raw Umber
Raw Sienna
Coeruleum
Cobalt Blue
Titanium White
Naples Yellow
Cadmium Red Light

1 Draw in the overall composition with charcoal. Using the flat brush, mix French Ultramarine and Raw Umber for the darkest rocks, with Raw Sienna added for the sunlit areas. Add plenty of medium to keep your colours thin and translucent, so that the brush strokes show clearly. Use both wide brush strokes and the edge of the brush to create an interesting surface for the rocks, and then put in their reflections with smooth vertical brush strokes.

2 Put in the sky but leave gaps for the clouds. This will make it easier for you to concentrate on the changing colour of the sky, from warm blue to cool cream towards the horizon. Start at the top, using Coeruleum and Cobalt Blue with a little Titanium White, changing to Naples Yellow and Titanium White nearer the horizon. Then block in the water with Coeruleum, Raw Sienna and Titanium White, again leaving gaps for the breaking surf.

3 Paint the clouds, using a warm grey and adding highlights with thick impasto marks of Titanium White. Add darker tones to the sea to suggest movement and then put in the surf, using Titanium White (no medium) and short downward brush strokes. Start to block in the beach with Raw Sienna and Titanium White, adding medium and blending the paint. Add wet streaks to the beach with Coeruleum and Titanium White.

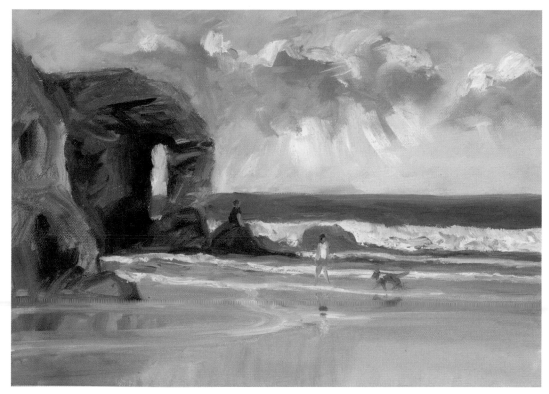

◀ **Cornish Beach**
25.5 × 35.5 cm (10 × 14 in)

4 Finish painting the beach in the foreground and blend the wet streaks softly into the Raw Sienna. Change to the round brush to add the figures and dog. Mix Raw Sienna, Cadmium Red Light and Titanium White for a flesh tone. Put in the figures loosely, starting with the torsos. Paint the T-shirts and shorts, and then the heads, arms and legs. Use Raw Umber for the dog, with a little Titanium White for his collar. Finally, add reflections of the foreground figure and dog, using a few horizontal lines of paint applied with gentle pressure on to the wet surface of the beach.

FURTHER INFORMATION

Here are some organizations or resources that you might find useful to help you to develop your painting.

Art Magazines
The Artist, Caxton House, 63/65 High Street, Tenterden, Kent TN30 6BD; tel: 01580 763315
www.painters-online.com
Artists & Illustrators, 26-30 Old Church Street, London SW3 5BY; tel: 020 7349 3150
www.artistsandillustrators.co.uk
International Artist, P. O. Box 4316, Braintree, Essex CM7 4QZ; tel: 01371 811345
www.international-artist.com
Leisure Painter, Caxton House, 63/65 High Street, Tenterden, Kent TN30 6BD; tel: 01580 763315
www.painters-online.com

Art Materials
Daler-Rowney Ltd, P. O. Box 10, Bracknell, Berkshire RG12 8ST; tel: 01344 461000
www.daler-rowney.com
Finelife, Foxcombe, Exford, Minehead, Somerset TA24 7NY; tel: 01643 831336
www.pochade.org.uk

Jackson's Art Supplies Ltd, 1 Farleigh Place, London N16 7SX; tel: 0870 241 1849
www.jacksonsart.co.uk
Rosemary & Co. Quality Artists' Brushes Ltd, P. O. Box 372, Keighley, West Yorkshire BD20 6WZ; tel: 01535 600090
www.rosemaryandco.com
T. N. Lawrence & Son Ltd, 208 Portland Road, Hove, West Sussex BN3 5QT; tel: 0845 644 3232 or 01273 260260
www.lawrence.co.uk
Winsor & Newton, Whitefriars Avenue, Wealdstone, Harrow, Middlesex HA3 5RH; tel: 020 8424 3200
www.winsornewton.com

Art Shows
Affordable Art Fair, Sadler's House, 180 Lower Richmond Road, Putney Common, London SW15 1LY; tel: 020 8246 4848
www.affordableartfair.com
Art in Action, Waterperry House, Waterperry, Nr Wheatley, Oxfordshire OX33 1JZ; tel: 020 7381 3192 (for information)
www.artinaction.org.uk

Patchings Art, Craft & Design Festival, Patchings Art Centre, Patchings Farm, Oxton Road, Calverton, Nottinghamshire NG14 6NU; tel: 0115 965 3479
www.patchingsartcentre.co.uk

Art Societies
The Royal Institute of Oil Painters, The Mall Galleries, Carlton House Terrace, London SW1Y 5BD; tel: 020 7930 6844
www.theroi.org.uk
Society for All Artists (SAA), P. O. Box 50, Newark, Nottinghamshire NG23 5GY; tel: 01949 844050
www.saa.co.uk

Bookclubs for Artists
Artists' Choice, P. O. Box 3, Huntingdon, Cambridgeshire PE28 0QX; tel: 01832 710201
www.artists-choice.co.uk
Painting for Pleasure, Readers' Union, Brunel House, Forde Close, Newton Abbot, Devon TQ12 4PU; tel: 0870 4422033
www.readersunion.co.uk

Internet Resources

Artcourses: an easy way to find part-time classes, workshops and painting holidays in Britain and Europe
www.artcourses.co.uk
British Arts: useful information about all art-related matters
www.britisharts.co.uk
Galleryonthenet: provides member artists with gallery space on the internet
www.galleryonthe.net
Melanie Cambridge: the author's website, with details of her DVDs, painting courses and a gallery of her paintings
www.melaniecambridge.com
Open College of the Arts: an open-access college, offering home-study courses to students worldwide
www.oca-uk.com
Painters Online: interactive art club run by The Artist's Publishing Company for amateur and professional artists
www.painters-online.com
Watershed Studio: a popular venue for top-quality one- and two-day art courses in all media and for artists of all levels of ability
www.watershedstudio.co.uk

Videos/DVDs

APV Films, 6 Alexandra Square, Chipping Norton, Oxfordshire OX7 5HL; tel: 01608 641798
www.apvfilms.com
Teaching Art, P. O. Box 50, Newark, Nottinghamshire NG23 5GY; tel: 01949 844050
www.teachingart.co.uk
Town House Films, Norwich Business Park, Whiting Road, Norwich NR4 6DN; tel: 01603 281007
www.townhousefilms.com

FURTHER READING

Why not have a look at other art instruction titles from Collins?

Bellamy, David, *Learn to Paint Watercolour Landscapes*
Blockley, Ann, *Learn to Paint Country Flowers in Watercolour*
 Watercolour Textures
Cambridge, Melanie, *Learn to Paint Landscapes in Oils*
 Success with Oils
 You Can Paint Acrylics

Crawshaw, Alwyn, *30-minute Sketching*
 Alwyn Crawshaw's Ultimate Painting Course
Evans, Margaret, *30-minute Pastels*
French, Soraya, *30-minute Acrylics*
 Dynamic Acrylics
Jennings, Simon, *Collins Artist's Colour Manual*
 Collins Complete Artist's Manual
Peart, Fiona, *30-minute Watercolours*
Simmonds, Jackie, *Gem Sketching*
Soan, Hazel, *Gem 10-minute Watercolours*
 Learn to Paint Light and Shade in Watercolour
 Secrets of Watercolour Success
Talbot-Greaves, Paul, *30-minute Landscapes in Watercolour*
Trevena, Shirley, *Vibrant Watercolours*
Waugh, Trevor, *30-minute Flowers in Watercolour*
 30-minute People in Watercolour
 Winning with Watercolour
Whitton, Judi, *Loosen up your Watercolours*

For further information about Collins books visit our website:
www.collins.co.uk

INDEX